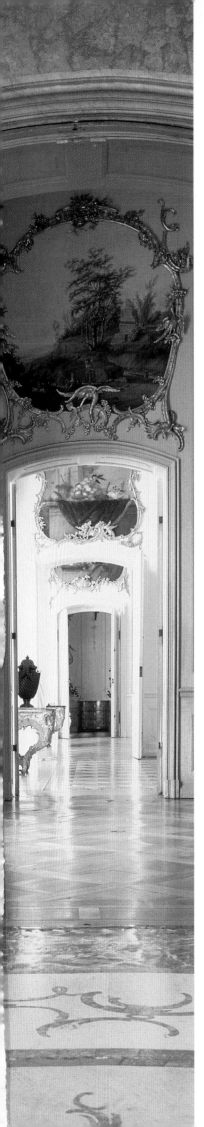

STIFTUNG
PREUSSISCHE SCHLÖSSER UND GÄRTEN
BERLIN-BRANDENBURG

Petra Wesch

Sanssouci

The Summer Residence
of Frederick the Great

in collaboration with
Rosemarie Heise-Schirdewan
and
Bärbel Stranka

Prestel

Munich · Berlin · London · New York

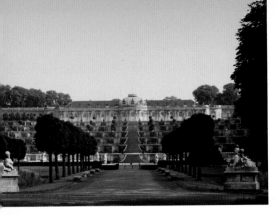

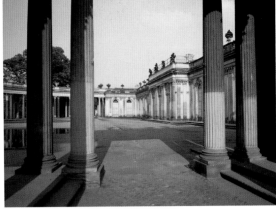

CONTENTS

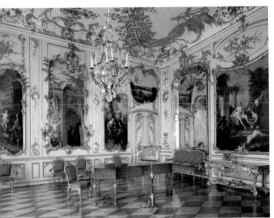

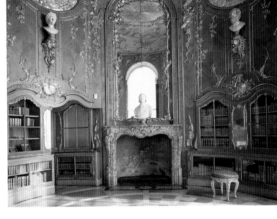

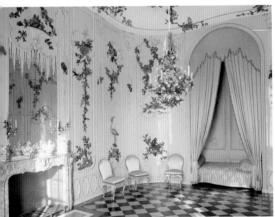

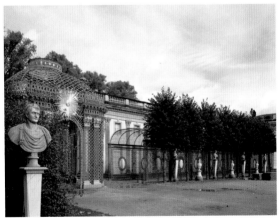

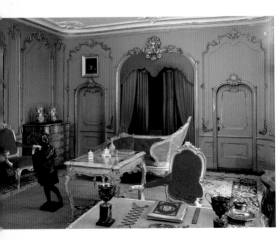

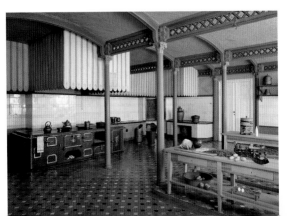

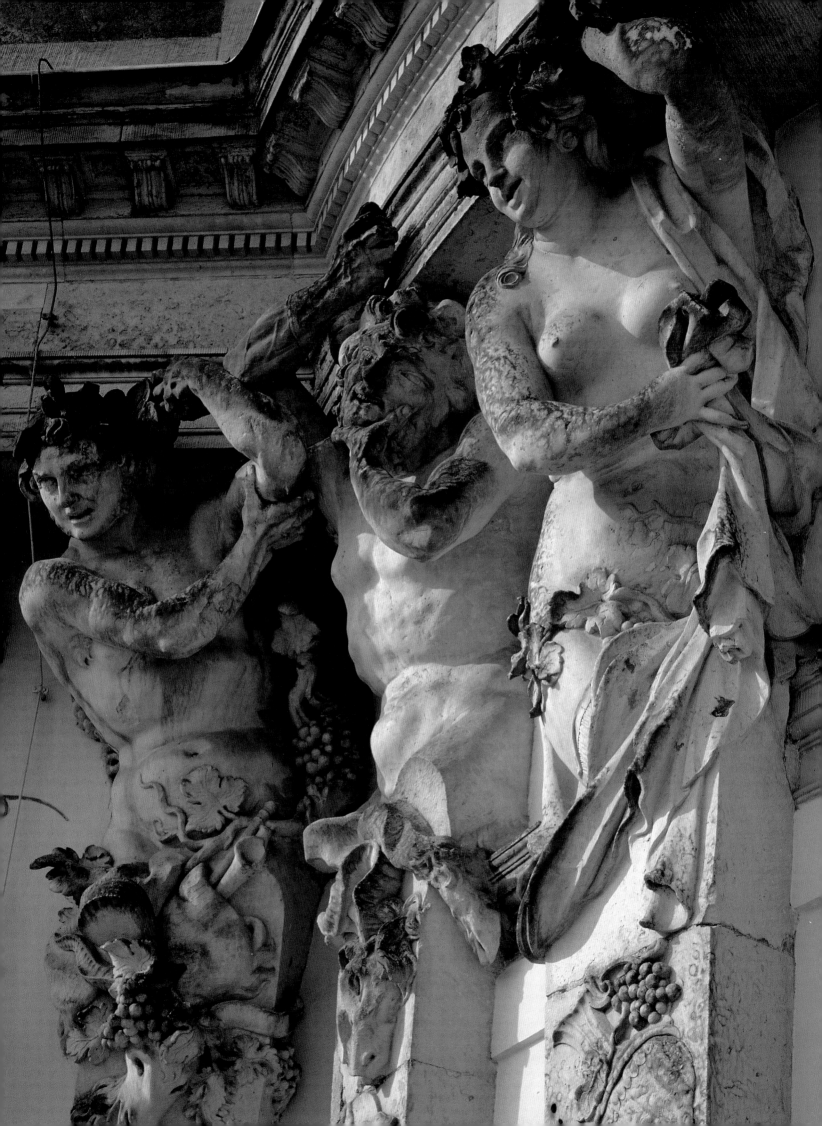

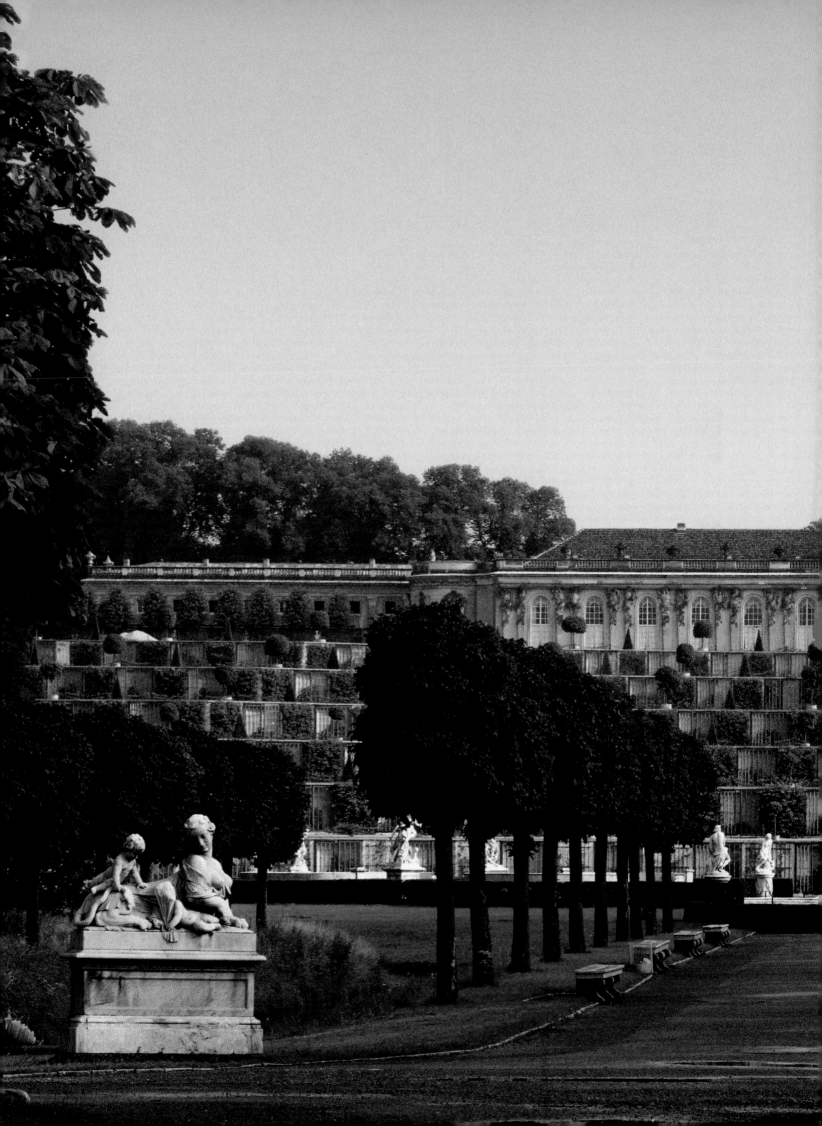

Sanssouci

Sanssouci and Frederick the Great

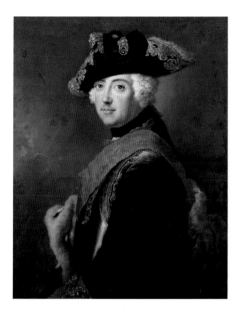

Painting of Frederick II wearing a crimson coat with ermine trimmings, the sash of the Order of the Black Eagle and a tricorn adorned with intricate braidwork, by Antoine Pesne (1683–1757), 1740.

The palace of Sanssouci sits jewel-like atop terraces of vines. It is remarkable not only for its magnificent architecture and marvellous location, but also for its close association with the name of the man who had it built, Frederick II "the Great".

He was born on 24 January 1712, a scion of the House of Hohenzollern and son of the future "Soldier-King", Frederick William I, and Sophia Dorothea of Hanover. An uncompromising disciplinarian, Frederick William I attempted to make of his son a monarch both rational and militant, as he himself was. Much to his father's regret, and against his instructions, the young Frederick took an interest in art and philosophy, played music, wrote poetry and later corresponded extensively with the leading scientists and philosophers of his age. On his death, in 1740, the "Soldier-King" left behind a well-organized, centralist administration and had transformed his parents' former "Court of the Muses" into a "Sparta of the North". Expectantly, all of Europe now looked to the new King, a man of the Enlightenment, a man with musical training, a man who knew how to win others over with his charm.

Not only the Empress Maria Theresa of Austria soon had cause to be appalled at the other side of his personality. She came to know "the evil man" as a cool, calculating power broker who conquered Silesia and precipitated the War of the Austrian Succession (1740–48).

In times of peace, Frederick the Great again conformed to the image of the enlightened monarch and "prince of peace" and spent the warm summer months at his small residence of Sanssouci, where, in the vineyard outside Potsdam, Europe's greatest minds joined him for dinner to discuss everything under the sun and to listen to the "philosopher-king of Sanssouci" playing the flute.

Yet there was one thing that Frederick the Great never forgot: that as King, he had a duty to perform. While Louis XIV had declared "I am the State!", Frederick II described himself as "the first servant of the State". A raft of laws and commands was issued from the palace every day. The King left nothing to look after itself. Especially after the Seven Years' War, he became ever more distrustful and personally saw to it that his instructions and orders were carried out. Although gout caused him to walk with a stoop, he set off on tours of inspection supported by a walking stick. Once Frederick "the Great", he became "Old Fritz". Becoming ever more cynical and embittered, he failed to read the signs of the new age of the French Revolution. With an iron will, he kept the reins of power in his own hands and resisted new ideas. Frederick the Great died on 17 August 1786. The allure of the great ruler, however, lives on. Today, Sanssouci attracts more than 300,000 visitors to Potsdam each year. Statesmen, too, from Napoleon to Bill Clinton, have gone in search of the myth of the man who was a legend even in his own lifetime.

Architectural History

Sanssouci's story began when a party set out on horseback for a picnic not far from Potsdam in August 1743. "Yesterday we picnicked atop the hill, from where the view is delightful." However, some time would pass between this initial enthusiasm for the site and the grand plan of building a palace on it.

At first, Frederick thought of creating only a vineyard. He acquired the "desolate hill" from the orphanage in Potsdam, had it surveyed and on 10 August 1744, a Cabinet instruction was issued to lay out a vineyard on it.

The parabolic terraces curve inwards so as to trap as much sun as possible. Costly vines from Italy, Portugal and France could thus be grown in addition to native ones. Even figs ripened in glass-covered niches. As early as 1744, Frederick the Great took the unusual decision to have his tomb built on the uppermost terrace. His intention was to create a new Arcadia, where, for the enlightened prince, death also had its place.

When exactly the King first thought of building his hilltop palace will probably remain a mystery; what we do know is that its foundation stone was laid on 14 April 1745. After only two years of construction work, the *Spenersche Zeitung* reported the following: "His Majesty the King yesterday took up residence in his newly built and exceptionally splendid summer palace of Sanssouci outside Potsdam, and there lunched at a table laid for 200...".

Letters and his own drawings show just how great an interest the King took in the construction of his refuge outside Potsdam. Even during the Second Silesian War, in 1745, he insisted that job records and cost estimates be sent to him and ordered the project engineers to report to him in the field.

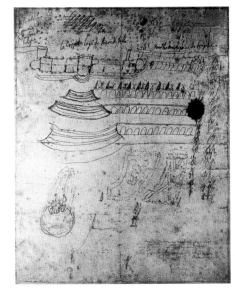

In oblique projection as used by soldiers, a drawing by Frederick the Great from 1744 shows the ground plan of the palace of Sanssouci and its terraces. With this "bird's-eye view", the King was able, simply yet effectively, to express what he wanted. It then fell to his architect to realize his vision.

Carved in sandstone, the merry followers of Bacchus, god of wine, gladly take the palace motto "sans souci" to heart. The first drawings were done by the palace architect, Georg Wenzeslaus von Knobelsdorff (1699–1753); these lively figures were carved by Friedrich Christian Glume (1714–1752).

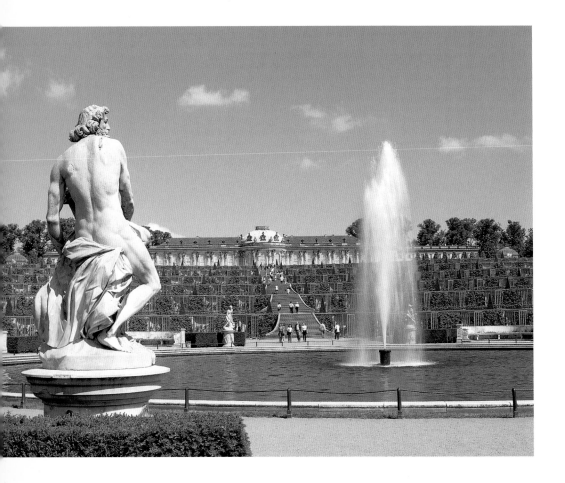

The large *rondelle* beneath Sanssouci is surrounded by masterpieces of French sculpture. Besides works by the brothers Lambert-Sigisbert (1700–1759) and François-Gérard (1710–1761) Adam, there are two figures by Jean-Baptiste Pigalle (1714–1785), gifts from Louis XV to Frederick the Great.

Following double-page spread: View of the terraces of vines and the palace from the *rondelle*.

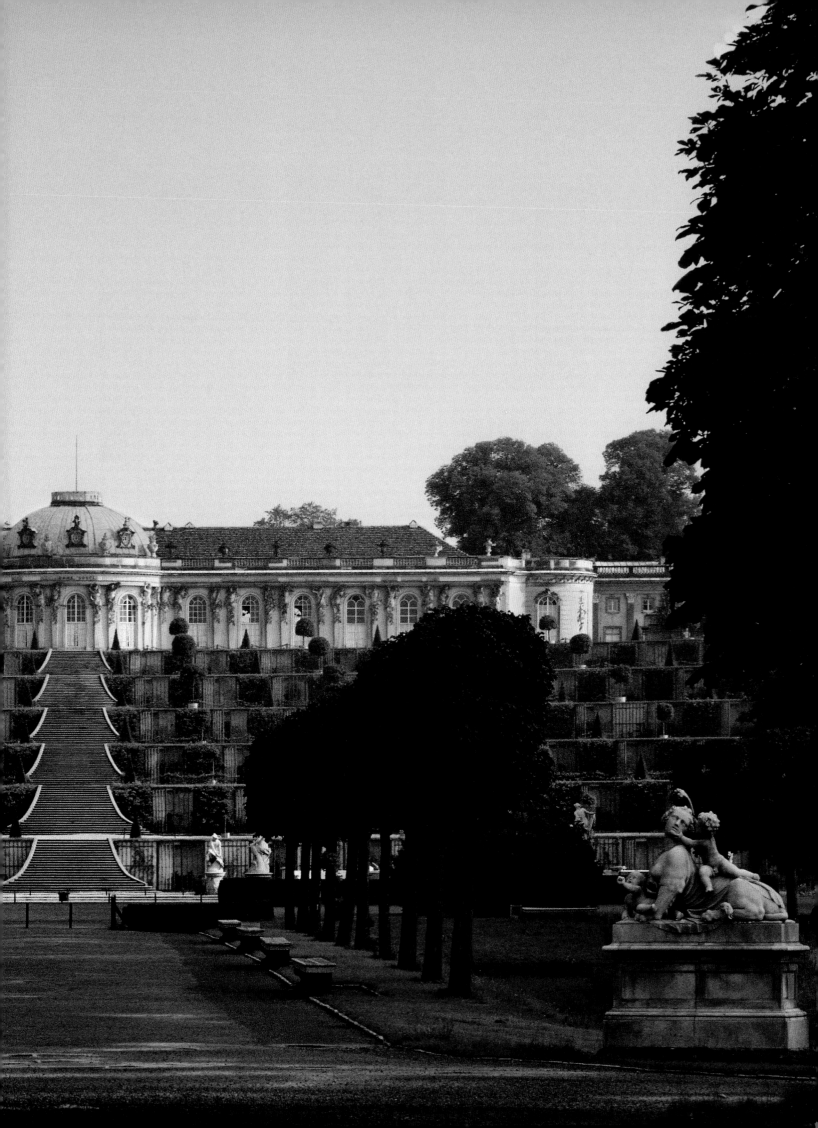

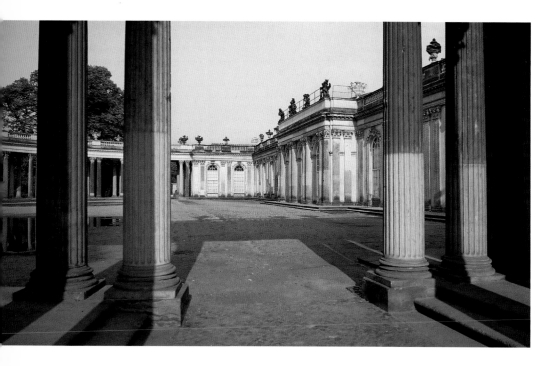

Frederick the Great's ideas on architecture were greatly indebted to Italian and French theoreticians. Based largely on the "châteaux de plaisance" that were then in vogue, the palace was designed according to the requirements of its owner. For instance, the Library, a place for intense concentration, is situated away from the palace's succession of rooms and may be reached only through a separate passageway.

Georg Wenzeslaus von Knobelsdorff, Prussia's foremost architect in the 18th century, already knew his client from having worked on the enlargement of the palace at Rheinsberg when Frederick was still Crown Prince. It was not always easy for him to accommodate his client's highly individual wishes while remaining true to his own artistic visions. Trained both in the classical forms of antiquity and contemporary French style, Knobelsdorff designed a well-proportioned palace whose lightness and elegance epitomize Rococo style.

Seen from the garden, the palace is graced with a lively façade. A spirited party of male and female followers of Bacchus in sandstone again takes up the motif of the vineyard and the palace, "sans souci" – carefree.

In the *cour d'honneur* (Ehrenhof), an imposing colonnade receives visitors. The sight is almost Neoclassical and emphasizes the official character of the building: at Sanssouci, Frederick the Great was not only a clever and witty host, but was – above all else – King.

Not until Frederick William IV's accession to the throne, in 1840, were the palace's side wings lengthened and a new storey added. The art-loving King instructed his architects Ludwig Persius and Ferdinand Hesse to remain true to Knobelsdorff's use of forms so that the palace would retain its uniform appearance.

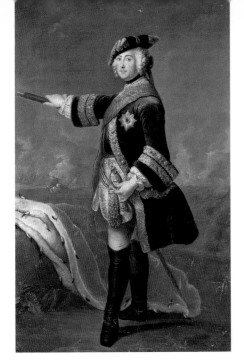

Frederick the Great, 1745, by Antoine Pesne (1683–1757).

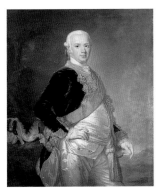

Frederick William II, c. 1773 by Anna Dorothea Therbusch (1721–1782).

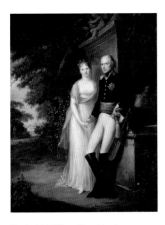

Frederick William III and Louisa in the grounds of Charlottenburg, 1799, by Friedrich Georg Weitsch (1758–1828).

Frederick William IV, 1820, by Ernst Gebauer (1782–1865).

Elizabeth of Bavaria as a Bride, c. 1823, by Joseph Karl Stieler (1781–1858).

Sanssouci and its Residents

Frederick the Great was unquestionably the palace's most famous resident. From 1747 until his death in 1786, he chose to live at Sanssouci during the summer months, except in time of war. Shortly after his accession to the throne, he banished Queen Elizabeth Christine from his company and sent her to the palace at Niederschönhausen. From the start, Sanssouci was intended solely for the use of the King and his guests. Of those who occupied the five guest rooms, we know the name only of the man who stayed in the last one. It was named after Count Rothenburg, who resided there every summer until his death in 1751.

Since Frederick the Great fathered no children, he appointed his nephew, Frederick William, as his successor. As Frederick William II, he did not remain at Sanssouci for long, as the "Marmorpalais" (Marble Palace) was completed by 1791. Before Frederick William II took up summer residence at Sanssouci, still in the year of his uncle's death, he had the study and royal bedchamber remodelled in Neoclassical style. Frederick the Great expressed his view of his successor in a letter to one of his ministers, Hoym: "... My nephew will squander the coffers of the State and will allow the army to deteriorate. Females will rule and the State will perish."

The son of Frederick William II, Frederick William III, likewise used the palace as a summer retreat, but made no changes to it. Queen Louisa, his consort known for her natural charm, possibly re-introduced some vivacity and wit to Sanssouci. Frederick the Great would certainly have enjoyed seeing her gallop fearlessly down the ramp between the terraces.

Frederick William IV, the eldest son of Queen Louisa and Frederick William III, knew Sanssouci and its grounds intimately from an early age. Deeply respectful of Frederick the Great, he made no changes to his private apartments. After 1835, he and his wife, Elizabeth of Bavaria, moved into the guest rooms and he had alterations made to the palace's side wings to accommodate his guests and the royal household. Frederick William IV enjoyed staying at Sanssouci and died there in 1861. His widow lived there, too, until her death in 1873. Thereafter, Frederick the Great's favourite palace became a museum.

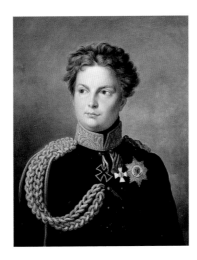

The Vestibule – Entrez, s'il vous plaît

From the *cour d'honneur* in the north, the palace is entered through the Vestibule. Its function, like that of the *cour d'honneur*'s façade, is expressed by economy of design. Graceful shades of silver-grey and gold emphasize the Vestibule's function as a room where guests were received. Ten pairs of imitation marble Corinthian columns with gilded capitals and bases dominate the architecture here. The room's clear structure is disrupted by lively and playful Rococo designs that are also found in Johann Harper's (1688–1746) ceiling painting from 1746. It shows Flora, the goddess of flowering plants, and guardian spirits floating on clouds and showering the earth – and the guests as they enter – with flowers and fruit. The gilt ornamental reliefs above the doors are taken from the legend of Bacchus and depict nymphs dancing around a herm of Pan, Bacchus's triumphal procession and the intoxicated march of Silenus. Exuberant gilded rocaille ornamentation carved on the door panels depicts vases with vine shoots, garlanded herms and musical emblems that are characteristic of the palace in its vineyard setting.

The high windows look out across the *cour d'honneur*'s to the Ruinenberg ("hill of ruins") opposite. Knobelsdorff and the Italian scene painter Bellavite created an ensemble of Classical-looking artificial ruins that form an impressive backdrop. The "ruins" surround a reservoir built to feed the fountains in the park. Only a century later, with the help of steam-driven engines, was it possible to pump water from the River Havel up to the Ruinenberg. Frederick the Great received suggestions for the design of the Ruinenberg from his favourite sister, Margravine Wilhelmine of Brandenburg-Bayreuth, who had added artificial ruins to her gardens a few years earlier.

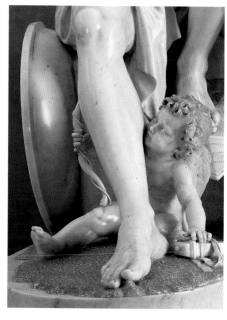

Detail of the statue of Mars and Cupid. Disarmed, Mars symbolizes the serenity of the palace.

The Vestibule affords a view across the *cour d'honneur* to the artificial ruins that recall ancient Rome.

Paired Corinthian columns, sparing use of forms and muted colours lend dignity and grace to the reception room. Playful Rococo elements and two marble statues offset the severity of the structure. Mars, the god of war, was masterly copied by Lambert-Sigisbert Adam (1700–1759) after an ancient model in Rome, and was given to Frederick the Great by the French King Louis XV in 1752. Opposite there originally stood a statue of Mercury, which was replaced by a copy of the Neapolitan statue of the seated Agrippina, created in 1846 by Heinrich Berges (1805–1852).

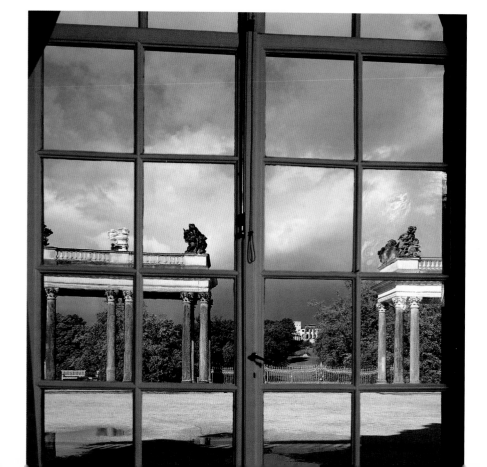

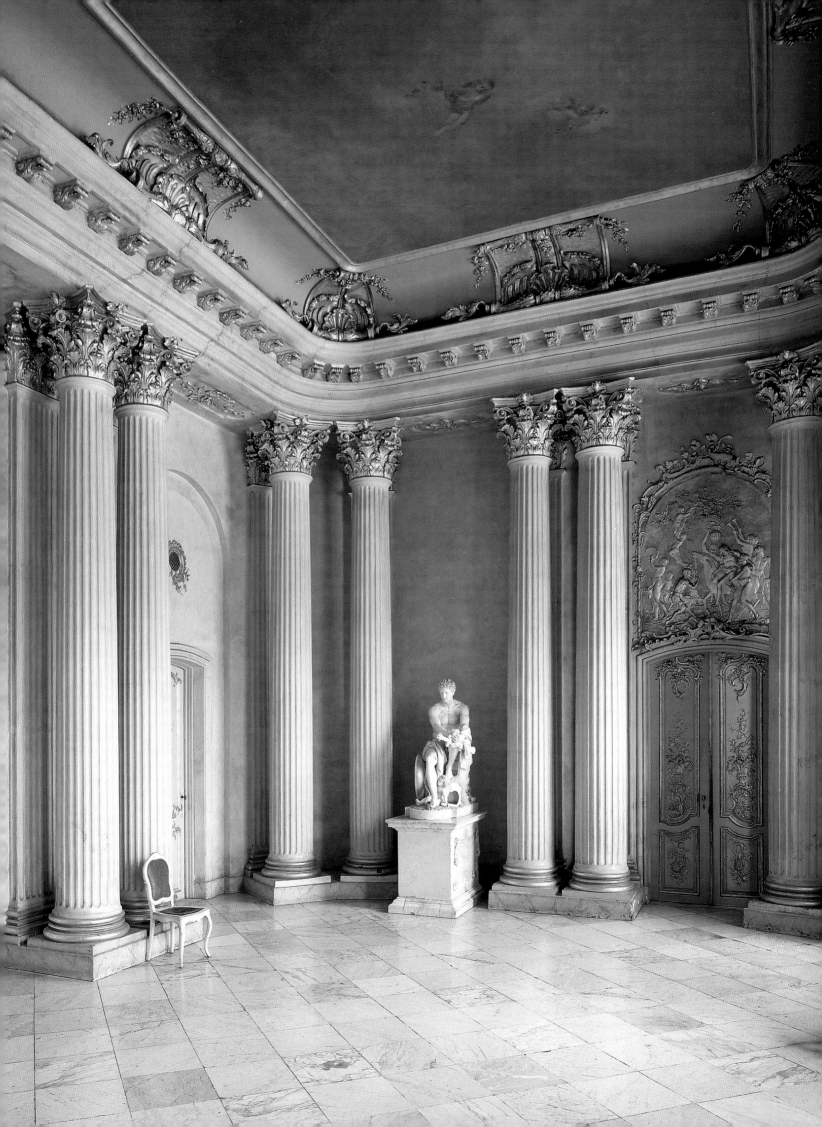

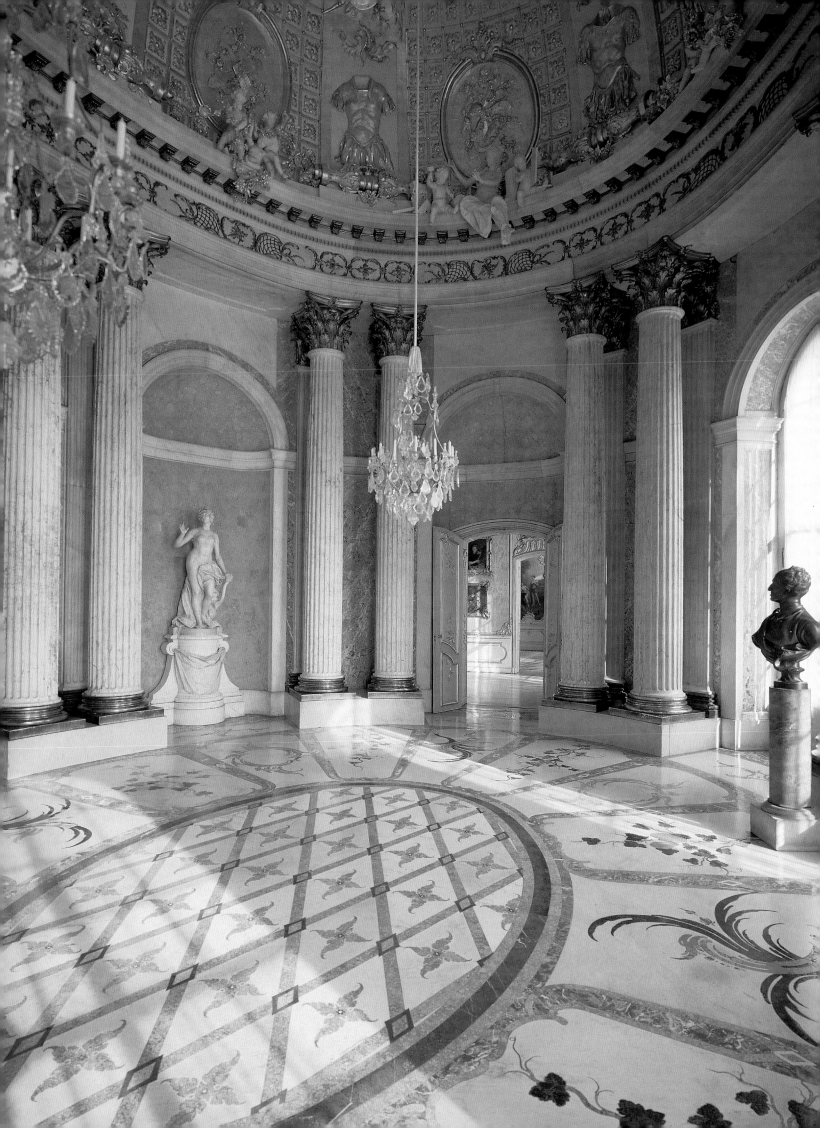

The Marble Hall

Heaven knows infinitely more than all the world's philosophers.
FREDERICK THE GREAT

As the focal point of the palace, the Marble Hall lends expression to the intellectual attitude and worldview of the man who had it built. The bust of the Swedish King Charles XII, by Jacques Philippe Bouchardon (1711–1753), was a gift from the Swedish Queen Louisa Ulrica, Frederick the Great's sister.

Like the Pantheon, the cupola opens out to the sky – but unlike its Roman predecessor, the cupola at Sanssouci was sealed with glass.

Behind the Vestibule lies the oval banqueting hall, which is formally broken up by eight paired Corinthian columns of Carrara marble. It was here that Frederick the Great famously entertained his guests. The column motif is first encountered in the courtyard colonnade and continues in the Vestibule, the Marble Hall and the caryatides on the palace's southern façade, ending in the garden in the form of yew pyramids and statuary. Whereas sandstone is used in the *cour d'honneur* and imitation marble in the Vestibule, true marble graces the Marble Hall to highlight its representative nature and its significance as the central point of the palace. The columns and floor blend harmoniously with the muted, earthy colours of the Italian marble walls, window jambs, alcoves and door recesses. Tall French windows on the south side of the "Salon à l'italienne" allow an even stream of light into the room and offer views of the gardens and the royal vineyard's uppermost terrace, where the King often walked, deep in thought, accompanied by his dogs. Knobelsdorff designed the room, with its eye in the cupola affording a view of the sky, in "free imitation of the

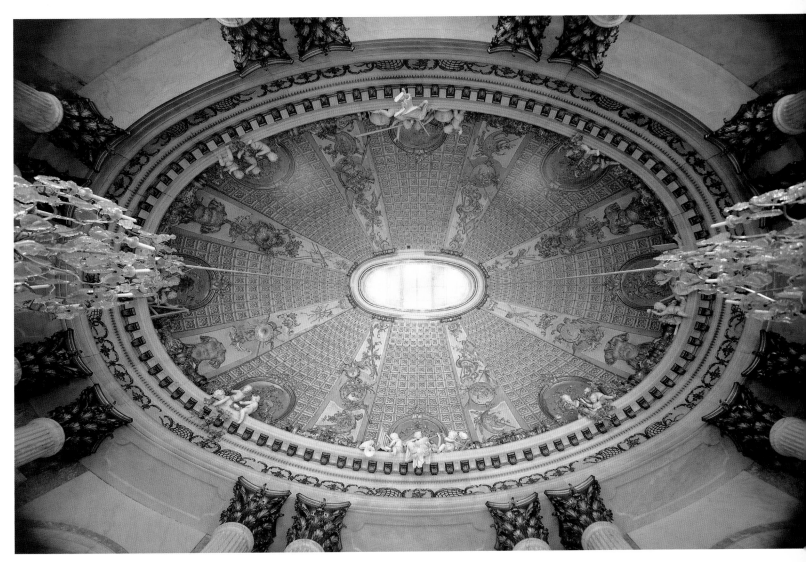

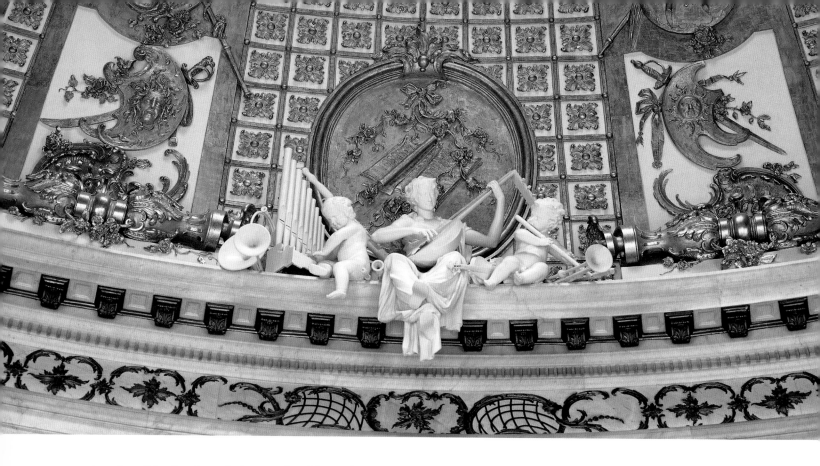

interior of the Pantheon", the temple of the gods in Rome, as Frederick II stressed in 1754 in a speech commemorating his late architect. With Sanssouci, the King succeeded brilliantly in creating a synthesis of French and Italian art. Here, in harmony with nature, he was able to pursue his interests of philosophy, literature, writing and music – free of cares and social constraints. The banqueting hall is overarched by a gilded stuccoed cupola, on the cornice of which allegorical female figures of architecture, music, painting, sculpture and astronomy sit. Amorini and putti frolick alongside them. The white marble floor, with its coloured inlaid work, reiterates the oval shape of the cupola.

A group of figures balancing on the cupola's cornice symbolizes music.

The marble floor contains decorative plant motifs; they are a reference to the fruit grown in the grounds of Sanssouci.

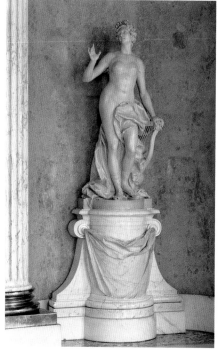

Flanking the door to the Vestibule are statues of Apollo and Venus Urania by François-Gérard Adam (1710–1761). Holding an open book, Apollo addresses Venus Urania, the Celestial Venus, with the words of the Roman poet Lucretius.

Guests at the King's Table

It was a special honour to be invited to dine at the King's table. His "table talks" were known for their frankness and cosmopolitan attitudes. Freiherr Jakob Friedrich von Bielfeld, the King's reader and constant travelling companion, wrote: "I do not believe that a circle of greater quality and distinction may be found in all of Europe than at this table. Frederick here lays aside his monarch's role, he is joyful and kind with his cheerful and witty companions ... hearts open up in turn and ... the intellect is freed from its shackles..." Art, literature, philosophy, religion, history and war, medicine and the sciences were discussed over many hours.

The most famous representatives of the Enlightenment met at the King's table, including the leading scientists and intellectuals of the day, among them the Italian philosopher and writer Count Francesco Algarotti, who was an especially welcome guest because of his amiable personality and sparkling intellect and who, on the very day he took up residence at Sanssouci, was decorated with the order "Pour le Mérite"; the wise doctor and philosopher Julien Offray de la Mettrie; the author, friend and companion of the King, Marquis Jean-Baptiste d'Argens; the mathematician and explorer Pierre Louis Moreau de Maupertuis and the most celebrated of them all, the writer and philosopher François-Marie Arouet, better known as Voltaire, one of Europe's greatest intellects. At the age of twenty-four, Frederick offered his friendship to Voltaire, eighteen years his senior, and despite several disagreements, they remained friends until the Frenchman's death in 1778. At the invitation of the King, Voltaire arrived in Potsdam in July 1750 and quickly established himself as the focus of his host's table. He recalled: "... Nowhere on earth were man's superstitions discussed so freely, and never with such derision and contempt. God was exempt; but of those, who in His name had deceived their fellow men, no one was spared." Following Voltaire's dramatic departure in 1753, the "table talks" gradually came to an end. Their atmosphere was captured by the artist Adolph Menzel in his famous painting *Table Talk at Sanssouci* of 1849–50, his tribute to the "philosopher-king of Sanssouci".

Adolph Menzel (1815–1905) painted *Table Talk at Sanssouci* in 1849–50. Shown in animated conversation, from left to right, are: Lord Keith, tenth Earl Marischal of Scotland, Voltaire, General von Stille, Frederick the Great, Marquis Jean-Baptiste d'Argens, Field Marshal James Keith, Count Franceso Algarotti, Count Rothenburg and Julien Offray de la Mettrie.

The King's Apartments

The Audience Chamber

From the eastern side of the Marble Hall, a door leads into the King's apartments, the first of which is a small reception room. On cool, damp days, the gout-plagued King dined here alone or in company. A fireplace of Carrera marble heated the room. Beside it stands a small cedar sideboard with a marble top and side doors; wood for the fire was stored in it. The room was sparingly decorated to allow the collection of 18th-century French masters in their golden Baroque frames to be shown to best effect. The pictures were hung on shimmering violet-grey damask, "gris de lin", with a "Genoese" (floral) pattern. Today's silk covering is a faithful reproduction of a Berlin damask from around 1765. The ceiling painting is by Antoine Pesne (1747): the god of the west wind, Zephyr, is shown garlanding the goddess of flowering plants, Flora, while she rests upon clouds, both of them affectionately devoted to each other. Two small putti scatter flowers from a basket while a *genius* pours dew from the clouds. Soft, pastel hues convey the character of the early morning and of love, a theme taken up in the *sopraporta* of one of the doors leading to the Marble Hall. Putti are shown holding a book containing verses in French: "May the sun, when it makes its radiant return, still find us here in conversation about poetry and love, a promise of a yet lovelier day full of joys, let us then behold the flowers and the dawn." The lines of verse above the door to the Music Room urge those reading them to enjoy the moment as human existence is transitory.

The Audience Chamber also served as a dining room. Its plain walls provided a suitable background for the King's collection of paintings.

The *sopraporta* of one of the doors leading into the Marble Hall commends stimulating conversation among friends.

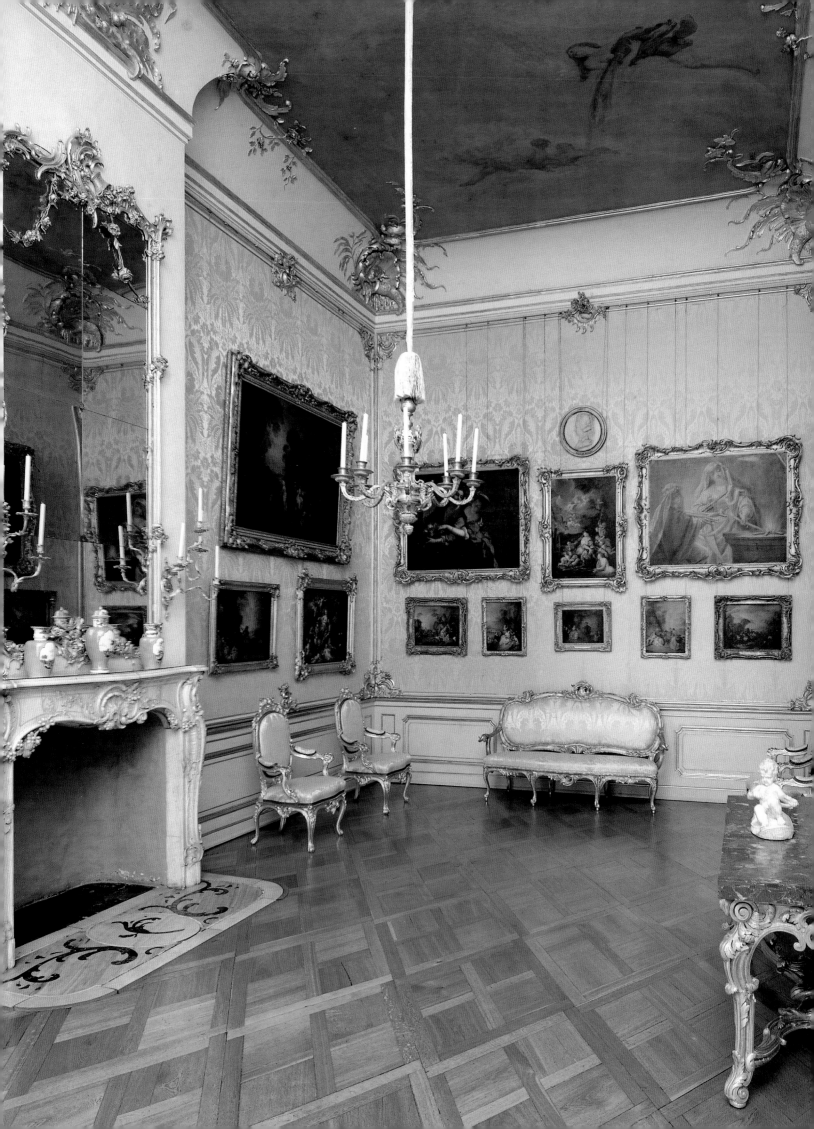

The Music Room – A Feast for the Senses

The Music Room is one of the loveliest Rococo interiors created under Frederick the Great. Its brilliant gold and white colour scheme creates a festive, lively atmosphere. Large mirrors reflect the flood of light from the windows opposite and the opulent decoration. This optical illusion makes everything appear brighter, larger and more splendid. The elegant, sweeping lines and delicate spirals of the ornamentation seem to evoke the sound of Frederick the Great's flute.

As to the interior decoration and furnishings, too, the King left nothing to chance. Under his influence, a unique style of Rococo developed. The name Rococo derives from the French word "rocaille", which signifies shellwork. With playful grace and an astonishing variety of forms, rocaille here fuses the whole interior of the room. Flowers and fruit entwine themselves around painted trelliswork and give one the feeling of being in a gilded bower. The mirrors, framed by what appears to be foliage, are set in niches and create the impression that there is another room full of greenery beyond. In an imagina-

The Music Room at Sanssouci is one of the loveliest Rococo interiors created under Frederick the Great. Besides being used for music-making, it was the place where after-dinner coffee was taken.

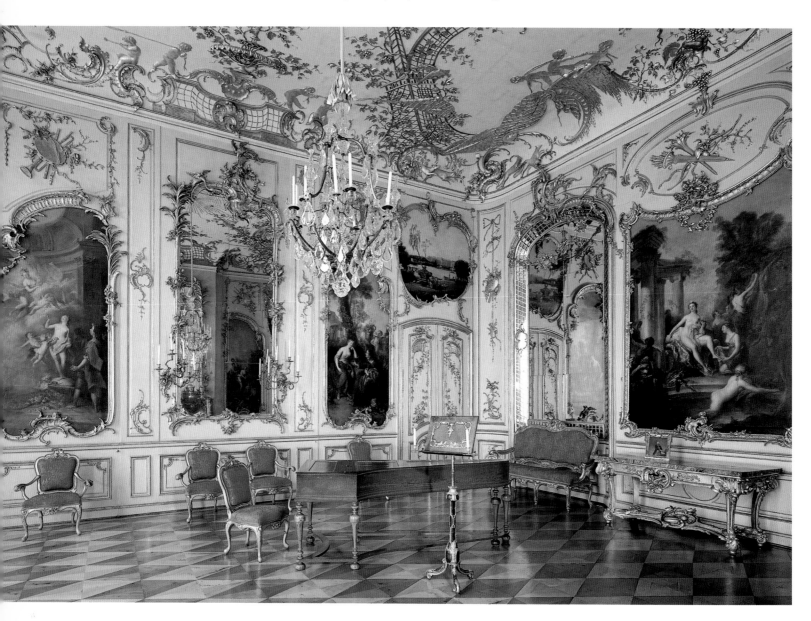

In the mid-18th century, the fancy shape of the shell (French "rocaille") was an obligatory stylistic element throughout Europe. It was found on delicate pieces of furniture, walls and doors, the façades of buildings and in garden borders.

An 18th-century palace without mirrors is unimaginable. They serve to magnify the splendour of the rooms and lend glamour to those living in them.

Following pages:
The idea of designing the Music Room as a plant-filled interior is taken up on the ceiling with effortless ease. The overall effect belies the fact that it is the work of several artists. The imaginative stuccowork on the ceiling is by Johann Michael Merck (1714–1784); the gold leaf was applied by Adam Carlony.

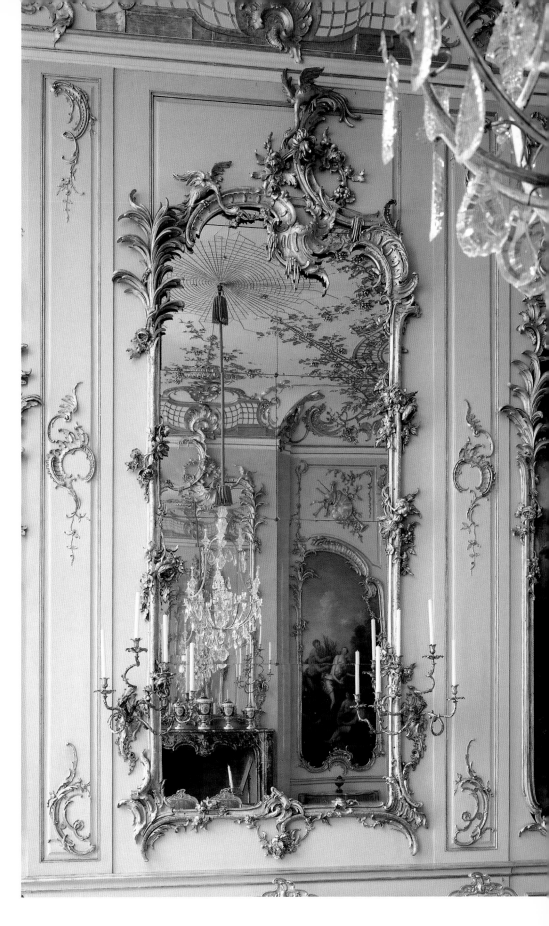

tive stroke, the delicate latticework spills over onto the ceiling and is held in place by a spider's web.

Putti and a wealth of animals are seen gambolling where walls and ceiling meet. The putti are shown trying to ensnare the animals with their nets; the animals, in turn, head off in every direction, but all in a spirit of fun – just as Rococo style would have it.

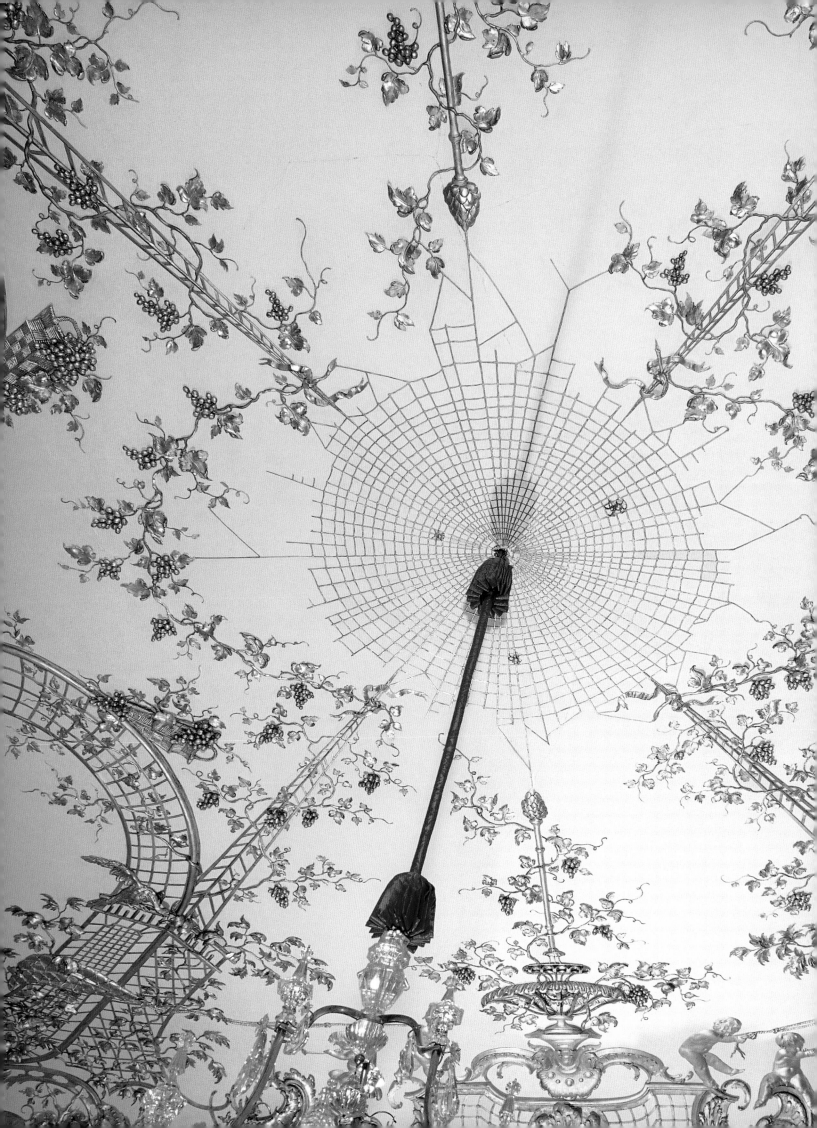

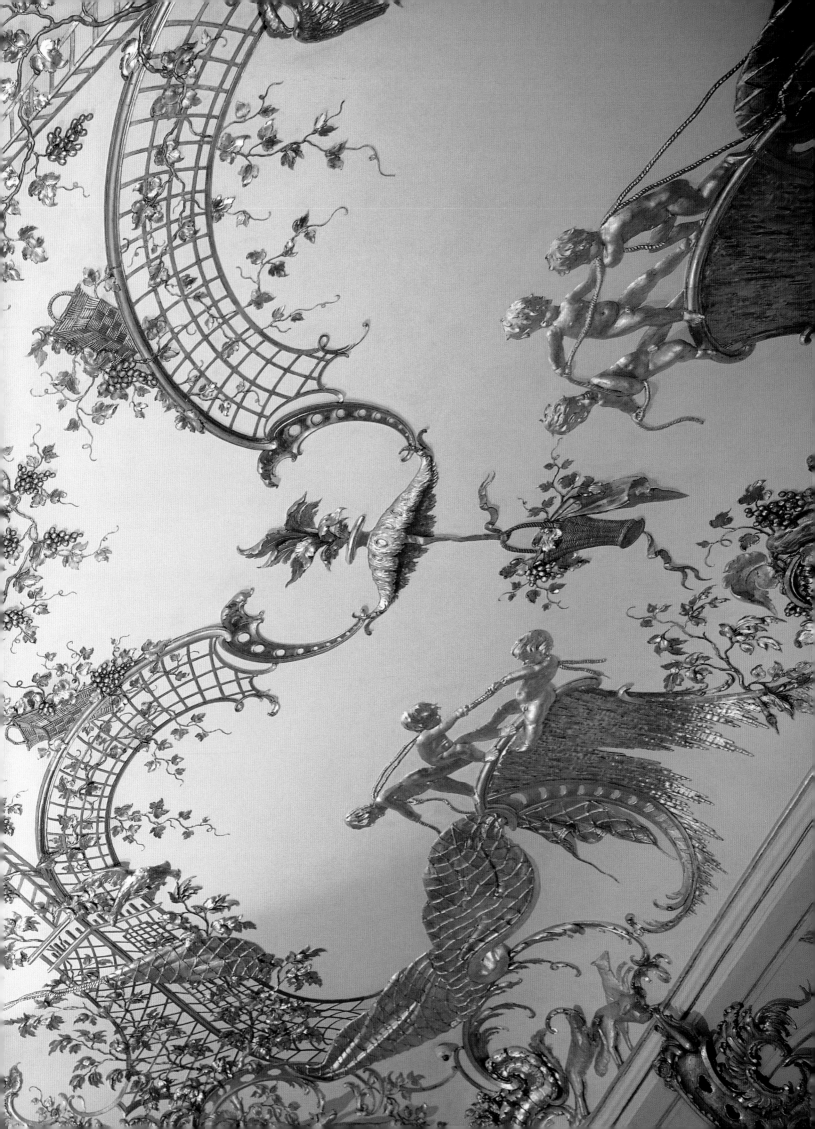

Antoine Pesne's wall paintings sit alongside the wall ornamentation with an equal ease. Frederick I called Pesne to the Prussian court to be its official painter and the artist later became a member of the Rheinsberg Circle around Crown Prince Frederick, when he developed his light, delicate painting style. Just as they are in the Music Room at Rheinsberg, his subjects here are taken from the Roman poet Ovid's *Metamorphoses*. Ovid was extremely popular in the 18th century because his transformation scenes from the world of the Gods allowed harmless associations to be made with secular rulers and his detailed descriptions could readily be turned into paintings. The central theme of all five paintings, set in natural surroundings, is the Gods' delight in love. Venus sets the tone and determines the fate of lovers.

In the mural painting *Pygmalion and Galatea*, she is clearly involved when her son Cupid breathes life into sweet Galatea, whose dance-like pose is reminiscent of the outstanding prima ballerina Barbarina, who in 1745 did indeed dance the role of Galatea at the Berlin Opera House. In the same year, Antoine Pesne completed a painting of her in Frederick the Great's private apartments. Just how highly the King regarded the dancer is reflected in her huge annual salary of 12,000 thalers. In contrast, the court harpsichordist, Carl Philipp Emanuel Bach, was worth a mere 300 thalers to the King. Yet Barbarina, too, came to know that it was the King who laid down the rules despite his good humour and gallantry. When she confidently decided in favour of her lover, the son of Prussia's chancellor Samuel von Cocceji, and demanded excessive amounts of money, she fell into disgrace in 1749 and had to leave Berlin.

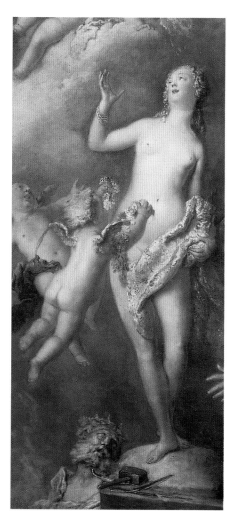

Detail of *Pygmalion and Galatea*.

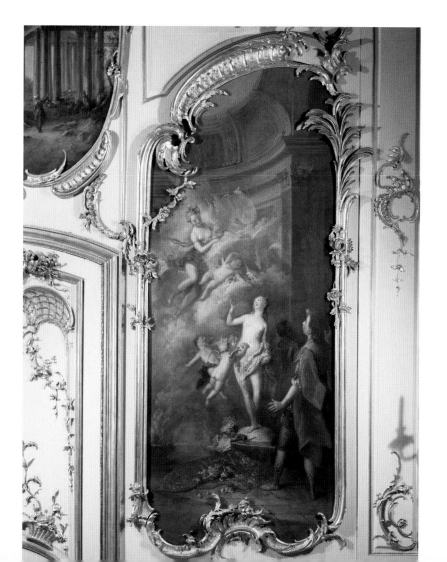

The painting on the wall is one of five by Antoine Pesne (1683–1757) in the Music Room at Sansssouci; like them, this one deals with Ovid's *Metamorphoses*, whose themes Frederick the Great loved dearly. Shown here is the tale of *Pygmalion and Galatea*. The sculptor Pygmalion fell so passionately in love with the marble statue he had created that Venus, the goddess of love, transformed the cold marble into a living Galatea.

The Flute Concert

Crystal chandeliers were reserved for the King's private apartments and banqueting halls. Made with rock crystal and bronze mountings, such a chandelier cost 3,000 thalers. In contrast, twelve paintings by his favourite French painters for Sanssouci's Little Gallery cost the King 3,500 thalers.

Inspired by the unique atmosphere of the Music Room, Adolph Menzel painted his famous work *The Flute Concert*. The room glows in the candlelight. Light is reflected in the shimmering silk and the gilded ornamentation on the walls. Everything is bathed in a warm light and delights the senses. Menzel is reputed to have said about this painting: "I painted it only for the sake of the chandelier. In *Table Talk at Sanssouci*, it is not in use, but here it's aglow."

In *The Flute Concert*, music is the focus of this socially disparate gathering. It is no ordinary concert for in it the King is shown playing his flute in honour of his favourite sister, Wilhelmine, Margravine of Brandenburg-Bayreuth, who visited him from August to December 1750. Fittingly, hers is the best seat on the sofa, in the middle below the large mirror. Wilhelmine appears absorbed in her brother's playing. Her sister, Princess Amalia, a feared music critic and expert, appears more interested in the woman sitting beside her. Johann Joachim Quantz, the King's old flute teacher, intently follows his former pupil's solo. The King set great store by his opinion. Quantz, incidentally, was the only one allowed to express criticism of the King's performance by means of a polite cough. It is said that the King played adagios superbly, which would explain why all 120 sonatas composed by him and the 200 composed by Quantz begin with an adagio passage!

As it was the King who decided what was played in his palaces and opera house, we cannot hold it against such an individualistic composer as Carl Philipp Emanuel Bach that he resigned his position at court. In this painting, however, he is still seen sitting patiently at his instrument in readiness for his performance.

This detail of *The Flute Concert* shows the King's sisters, Princess Amalia and, on the couch, his favourite sister, Wilhelmine, in whose honour the concert was held in 1750.

Adolph Menzel (1815–1905) began work on *The Flute Concert* in 1850. Fascinated by Frederick the Great, Menzel, who was both thorough and conscientious, was exacting in his study of his subject. Numerous studies and sketches were executed before he began work on the actual painting, which he completed in 1852.

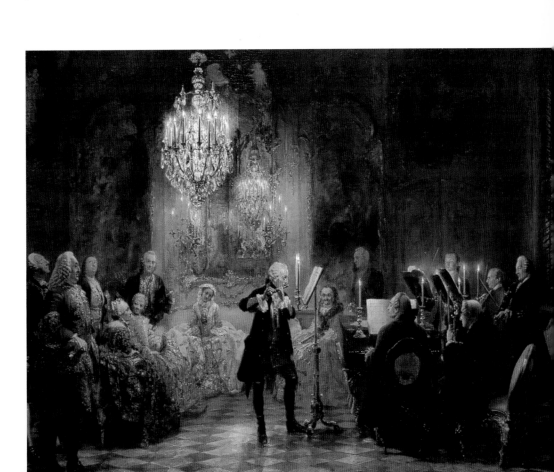

The Study and Bedchamber

With the exception of the Library, no other room at Sanssouci is so closely associated with Frederick the Great than his Study and Bedchamber. It was here that he made his feared marginal notes in letters and invoices, studied economics, politics and philosophy, issued commands and disciplined lackeys and officers alike. This is where he read books and fed his dogs small titbits, where he slept and, on 17 August 1786, died. Today's visitors see the room in early Neoclassical style. During Frederick's lifetime, the room was the highlight among his private apartments and was lavishly decorated in Rococo style. Sadly, no pictorial record of it has come down to us, but because others had access to the royal apartments during the King's absences, surviving contemporary accounts paint a lively picture of the palace and its residents.

The Marquis de Boullè, for instance, described the Study and Bedchamber thus: "... it is fitted out with numerous mirrors and divided by the large balustrade that marks the position of the King's bed. But it had in fact been raised next to the fire behind the bed screen, a simple campbed covered with a dark red taffeta cover that was just as unkempt as the other pieces of furniture, the reason being the numerous dogs, loved by the King, that lived in the royal apartments. Similarly, several tables were covered in books lying around in disarray."

For his successor, Frederick William II, there seems to have been too much of an aura to the place. He had Wilhelm von Erdmannsdorff redesign the Study and Bedchamber, the only room in the palace to be changed, in the new, Neoclassical style, and had the furniture removed. Only the fireplace remained in the original style. Frederick William IV thought differently, however: he was greatly interested in Frederick the Great and his age. Some of Frederick's pieces of furniture were found and restored to their original locations or were replaced by other pieces from his possession. The Rococo furniture with its exuberant forms contrasts with the room's simple interior design, thus giving visitors an idea of how wide-ranging the tastes of the palace's residents were.

Frederick the Great's Study and Bedchamber was the only room redesigned in the Neoclassical style after his death. Since the mid-19th century, efforts have been made to restore its original furnishings. Items of furniture that belonged to the King, such as his writing table and chest of drawers, recall the room's most famous resident.

The shell-shaped and figurative bronze ornamentation of Frederick the Great's writing table. Unlike the heavy-looking console table, this piece of furniture seems to conceal its real structure. The table legs sweep gracefully down to rest on the floor seemingly weightlessly, very much in Rococo style.

Left: Even in this detail, the clean lines of the console table are apparent. Simple geometric forms characterize this piece of furniture. The rosewood is decorated with bronze fittings in the shape of palmettes and garlands that, in the Prussian style, run down the straight table legs. Known pejoratively in German as the *Zopfstil* – pigtail style – this late Rococo/early Neoclassical style was typical of many bourgeois homes in Potsdam at the end of the 18th century.

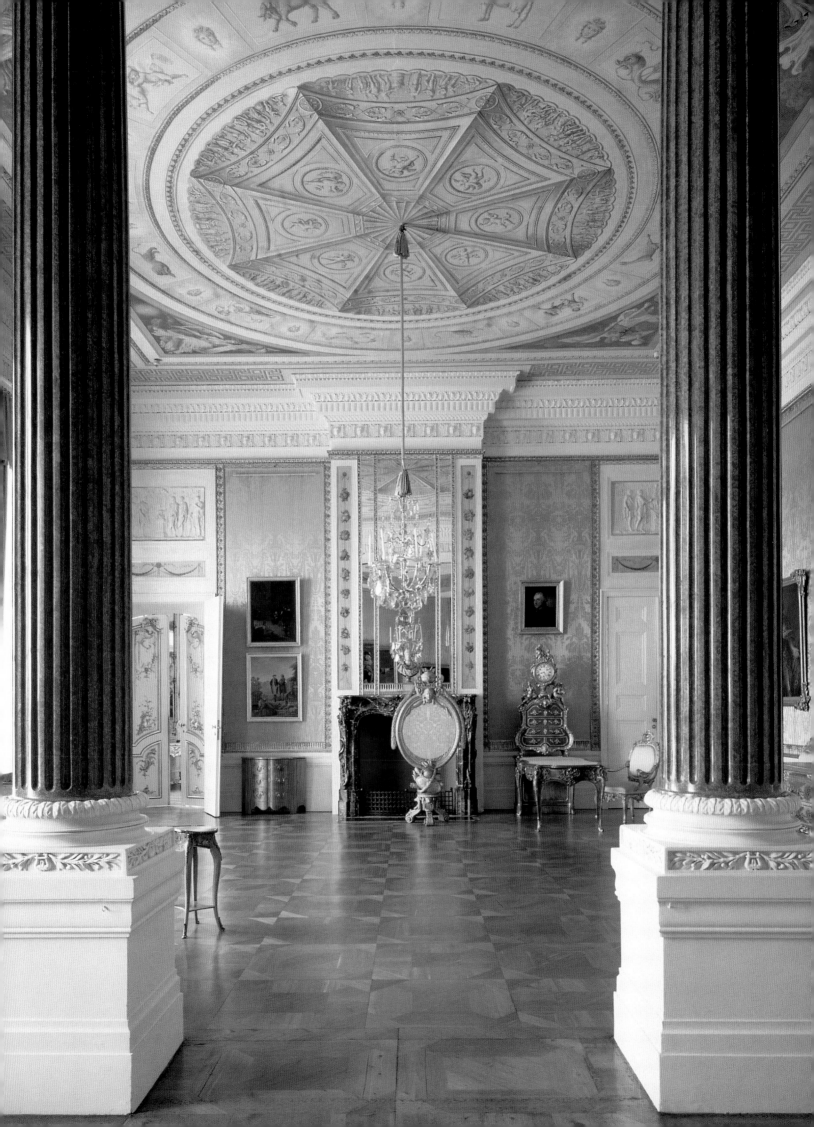

Portraits of the King

The walls in the Study and Bedchamber were once hung with green satin. A design of gilt trelliswork bearing flowers and birds permitted no other decoration, not even paintings. For Frederick, it was inconceivable that he could have pictures of himself in his rooms. He loathed the thought of being a cult figure and sitting for a portrait.

Several of his likenesses are now on display here. In the alcove, court painter Antoine Pesne's representative work from 1745 portrays Frederick as a self-assured military commander. This was the year when the King won the Second Silesian War and was first publicly referred to as Frederick "the Great".

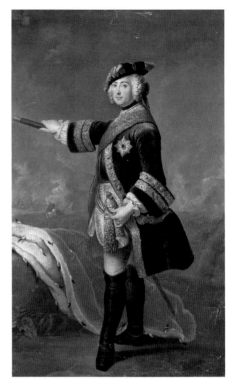

This portrait by Antoine Pesne (1683–1757) of 1745 shows Frederick the Great as a formidable military commander.

Another portrait was painted following the Seven Years' War, which also ended in the King's favour. The artist, Johann Georg Ziesenis, avoids any hint of the representative and Baroque, however. No ermine coat refers to the King's status; his soldier's coat is simple and modestly bears the Order of the Black Eagle. As he grew older, the King placed less and less importance on his appearance.

Many of his closest friends had already died. Fewer celebrations were being held. Plagued by gout, the King was becoming ever more ill-tempered and lonely.

Frederick's working day began between 4 and 5 a.m. Five hours' sleep had to suffice in a war-ravaged country in need of re-building. Suspecting that his instructions were not being followed, he set off on tours of inspection. People soon came to recognize him, an old man bent double with illness, supported by his walking stick and often accompanied by his favourite dogs. Frederick "the Great" had become "Old Fritz".

Far left: Johann Georg Ziesenis (1716–1776) painted this portrait of Frederick the Great in simple blue soldier's garb after the Seven Years' War; it served no representative function.

Johann Gottfried Schadow (1764–1850) possessed some items of Frederick's original uniform. In 1821, he wrote about his work on the figure of the King: "To pass time, I am now modelling a half-size figure of King Frederick with his walking stick, his left arm resting on his side, in an ordinary pose. Let us see what the effect is of such a dummy. As accessories, I will include some of his small greyhounds, qui faisant la distraction du grand Monarque." The names "Alkmene" and "Hasenfuss" are shown on their collars.

Precious items of furniture add a perfect touch to the room. The wonderful mahogany desk with its matching chest of drawers surmounted by a clock was acquired for Frederick in Paris in 1746 by his friend Count Rothenburg. The curvaceous furniture is elaborately adorned with gilt bronze fittings.

Frederick's palaces were nevertheless furnished largely with splendid items of furniture that were crafted locally. From the time of his accession to the throne, Frederick the Great was the greatest supporter and patron of the craft industry in Prussia. When Johann Melchior Kambly proved his ability as a cabinetmaker by finishing off the chest of drawers (on display in the third guest room), he received other demanding commissions, such as the music stand in the Music Room.

The music stand from the Music Room at Sanssouci attests to the great skill of its maker, Johann Melchior Kambly (1718–1783). Inlaid work using wood, ivory or mother-of-pearl was very popular during the Rococo period, as was the use of horn and tortoise-shell.

The writing table and matching chest of drawers surmounted by a clock are among the few items of furniture that were bought for the King in France. They were exemplary for the development of a Prussian style of furniture under Frederick the Great.

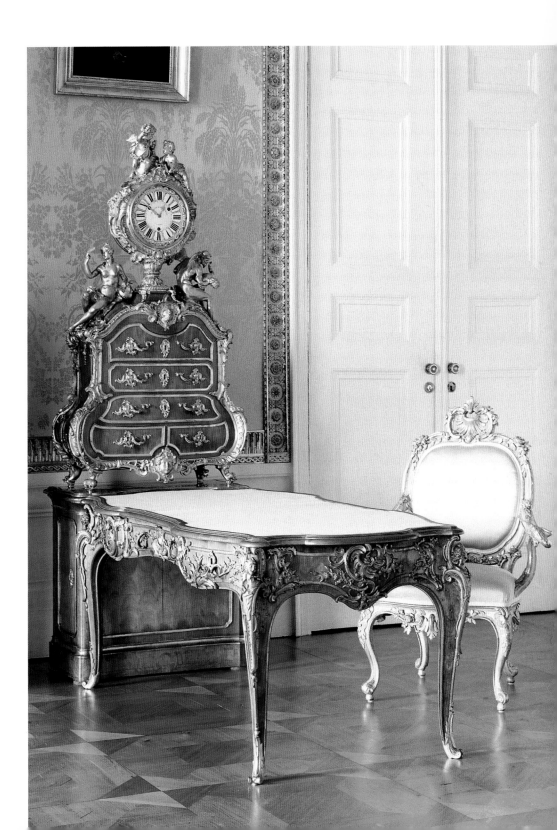

When Kings die

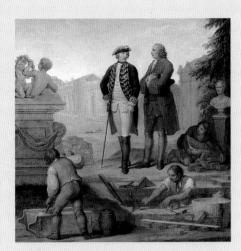

After his death, anecdotes often idealized the character of Frederick the Great. The small painting by Johann Christoph Frisch (1738–1815) shows the King and the Marquis d'Argens inspecting construction work on Frederick's tomb on the uppermost terrace. It was then that d'Argens suggested to the King that he could name the palace "Sans Souci". Frederick is said to have pointed to his future tomb and replied: "My dear Marquis, not until I'm in there will I be free of cares".

The death of a King is more of a public event than a private affair. True to tradition, Frederick the Great had his father's corpse laid out in state after which the "Soldier-King" was interred with royal ceremony. For himself, however, Frederick wanted something different. After the Silesian Wars, the question of death often preoccupied him and, in 1752 in his political last will and testament, he stated: "I have lived as a philosopher and wish to be buried as one – without pomp, without splendour and without ceremony ..."

Frederick the Great died in his study at 2:20 a.m. on 17 August 1786. In the eyes of his successor, Frederick William II, a simple tomb was unworthy of a King. After lying in state in the Stadtschloss, his body was transferred with great ceremony to the Garnisonkirche, where it was laid to rest beside the tomb of his father.

Yet Frederick the Great was to find no peace. During the Second World War, both coffins were evacuated to a potassium mine at Berntgerode in the Harz Mountains from where, by a circuitous route, they arrived at the chapel of Burg Hechingen, the seat of the Hohenzollern family, in 1952. Frederick's wish to be buried at Sanssouci was eventually granted by one of his descendants. On the 205th anniversary of his famous ancestor's death, and following German re-unification, Prince Louis Ferdinand, the then head of the House of Hohenzollern, had Frederick the Great interred in his tomb on the terrace at Sanssouci, on 17 August 1991. Pomp and ceremony were not dispensed with altogether, however. After all, it is a slightly different matter when a King is laid to rest.

Left: Frederick the Great died in this chair at 2:20 a.m. on 17 August 1786.

Right: The inerment ceremony of Frederick the Great in the *cour d'honneur* at Sanssouci, performed by the Guard of Honour of the German armed forces, 17 August 1991.

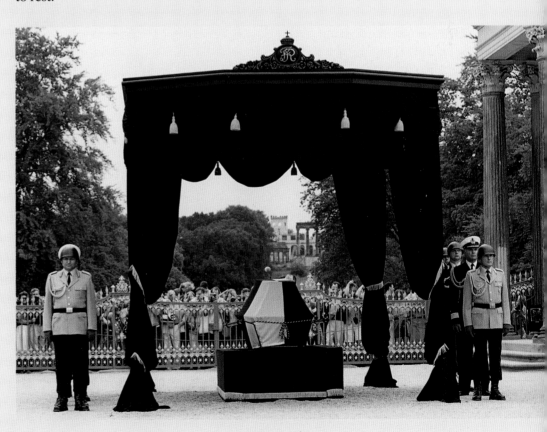

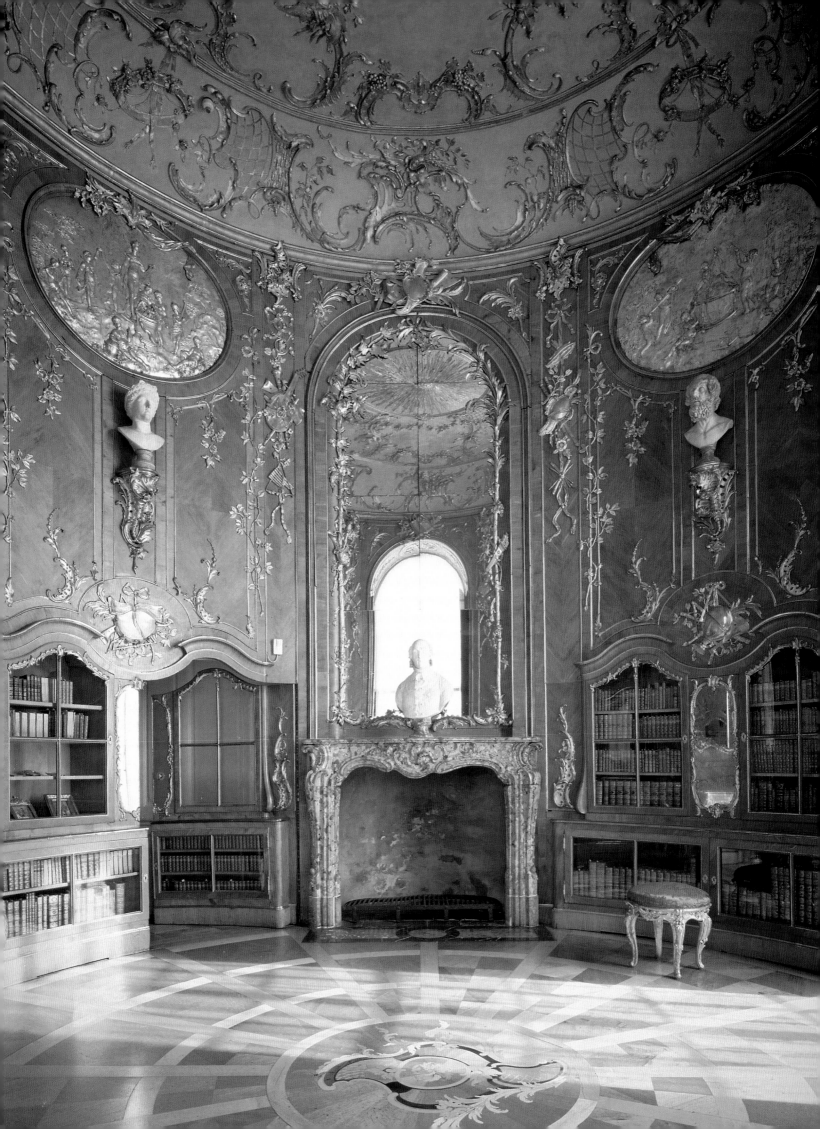

The design of the palace Library is among the master-
pieces of the variant of the Rococo style associated
with Frederick the Great. With its circular plan and
warm, wooden interior, it fulfils its scholarly purpose
and, for Frederick the Great, was a place of intense
concentration and intellectual stimulation. The door
is concealed within the book-lined wall, further
strengthening the room's intimate character. No visi-
tors were allowed here.

Right: Beside an open book a miniature painting of
the King is displayed on his writing table in the Library.

Frederick made a great effort to acquire the Greek
bronze sculpture *Youth Praying*. Found on Rhodes,
it frequently changed hands until the sovereign pur-
chased it from Prince Wenzel of Liechtenstein for
5,000 thalers in 1747. The original is now on display
in the Staatliche Museen, Berlin.

The Library

Sanssouci's Library is a gem. It is connected to the King's Study and Bedcham-
ber by a narrow passageway and he alone was permitted to set foot in it. Here,
too, Frederick the Great resorted to old ways. As was the case at Rheinsberg,
he had the Library built on a round plan at some distance from the other
rooms. It is the most intimate room in the palace
and one of the loveliest in the Rococo style built un-
der the sovereign. In contrast to the festive white
and gold of the Music Room, warm hues here cre-
ate a feeling of peace and harmony. Moreover, the
room's unusual shape emphasizes its intellectual
purpose. The circular cedar bookshelves are dec-
orated with gilt bronze ornaments. Cedarwood has
been highly prized since antiquity and was used
both in the construction of Solomon's temple and
the living quarters of the Pharaohs.

As in the Music Room, mirrors reflect the
daylight from the large French windows but in a far
more subdued way than there. A gilded sun shines
down from the circular ceiling, not so much as a
Baroque emblem of absolute power, but more as a
symbol of enlightenment and the Freemasons.
These were pretensions that Frederick the Great, an Enlightened Absolutist
and free thinker, combined in his person.

The bookcases are low so that Frederick, a man not much over five feet
in height, could comfortably reach them. The free wall space provided room
for ornamental reliefs. Sitting at his desk in the early morning, the King would
look towards the east into the sun and towards the famous figure *Youth Praying*.

The design of the room is again based on Frederick's express wishes.
Both the gilt reliefs and the antique busts on the consoles are a direct reference
to the Library's contents.

Frederick the Great's Collection of Books

Frederick the Great was a passionate collector of books. His interests ranged
from the complete works of Voltaire and other French authors, scientific and
architectural writings to Greek and Roman poets, philosophers and historians.
Seneca, Marcus Aurelius Antonius and Homer were among his favourite
authors. It is understandable that the most famous Roman replica of Homer
found its place alongside Seneca's bust in Frederick's Library.

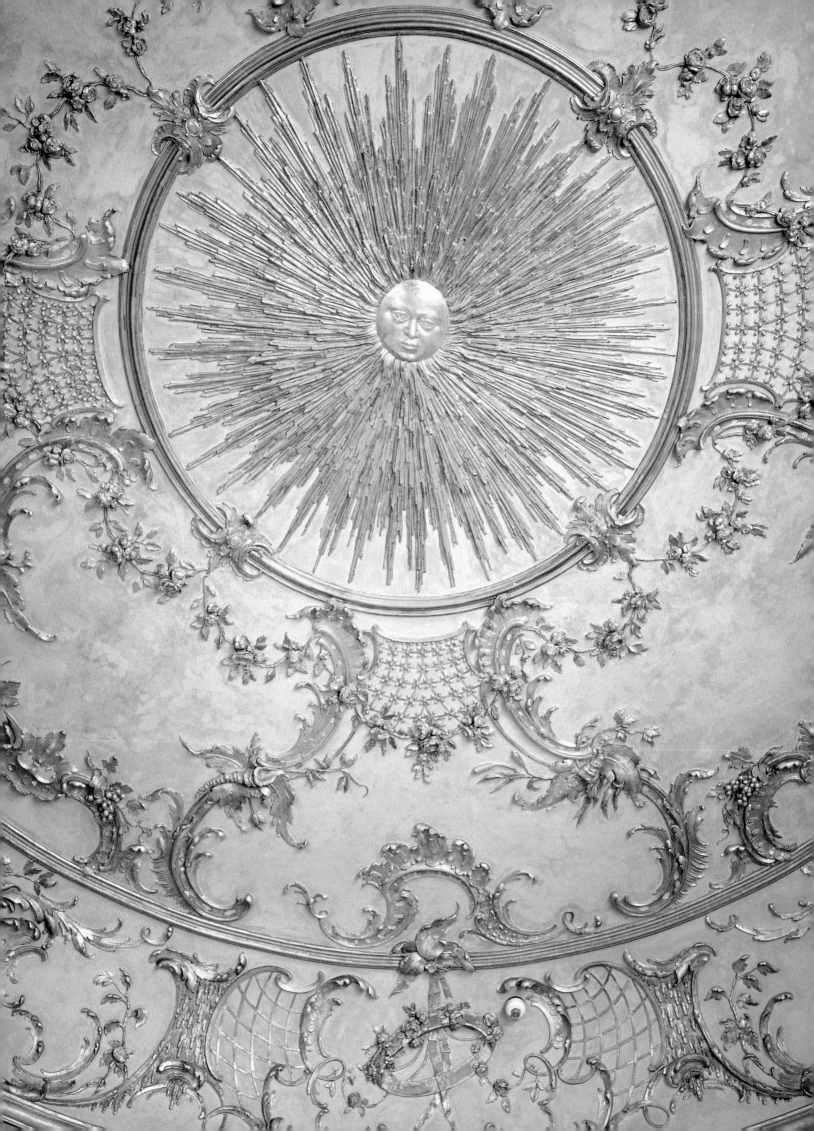

A gilded sun occupies the centre of the Library's ceiling. A symbol of the Freemasons, it is repeated in the pergolas on the palace terrace.

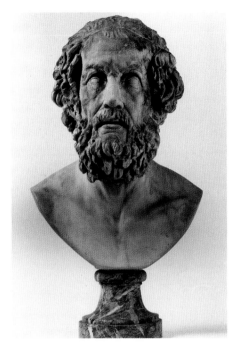

It is no coincidence that the bust of Homer and other figures from antiquity are displayed in Frederick's Library. They are expressions of his intellectual attachment to them.

More than 2,000 volumes are lined up behind glazed cedar shelves. Here, too, mirrors with delicate mountings magnify the room and reflect the warm light.

Frederick began collecting books in his early childhood. Encouraged by his French nanny and teacher, both Huguenots, he was an enthusiastic reader. Even the ruthless educational measures adopted by his father, Frederick William I, were unable to diminish his love of reading. At Sanssouci alone, there are 2,288 volumes, all in French. It is obvious just how much Frederick the Great valued his books: every one is bound in leather and those from Rheinsberg have elegant "Parisian bindings" of kid and calfskin. As the "Berlin bindings" were made locally, they were much less expensive, although they are of no less artistic value with their gilt decoration.

Impressed on the spine of all the volumes from Sanssouci is the letter "V" for "vigne" – vineyard. According to his reader, Frederick had always been careful in his handling of books. It was an idiosyncrasy of his to place all his unread books upright on the table and to lay those he had read across the top of them. The older Frederick became, the more books became "my main source of personal, spiritual joy and stimulation". In 1754, the King wrote to d'Argens: "I live with my books and associate with men from the age of Augustus. Soon I shall know the men of our century as poorly as formerly Jordan knew the streets of Berlin". Towards the end of Frederick's life, his six palace libraries were estimated to contain some 7,000 volumes.

In its plan, the Little Gallery is highly unusual. It connected the Vestibule with Frederick the Great's living quarters and served as a display area for part of the King's collection of paintings and sculptures.

The long room is broken up by alcoves on the side of the wall and mirrors on the window side. Whereas the sculptures in the alcoves barely stand out from the lightly coloured imitation marble behind them, the paintings gleam in their beautifully gilded wooden frames. Here, too, imaginative ornamental stuccowork enlivens the walls and mirrors. On the ceiling, playful putti strew flowers from the sky. Gold, muted shades of grey and shimmering violet-pink give the room a distinguished feel. In contrast, small bacchants intoxicated with wine cavort beneath the console tables. "Live and let live" is the message here. The narrow Rococo sofas against the walls prompted the landgravine of Hesse to comment pointedly after paying Frederick a visit that hooped skirts appeared to be unwanted here. For the King, "sans souci" meant "sans femme", "no women".

When it came to collecting paintings, Frederick the Great showed he had original taste, as he had in many other things. In the 18th century, Antoine Watteau was certainly not among the most respected of painters. Yet it was his art that influenced the variant of the Rococo style associated with Frederick

Besides antique sculptures, the young King Frederick had a particular liking for paintings by the French artist Antoine Watteau (1684–1721) and his pupils. Some of their work is displayed in the palace's Little Gallery.

The bust of Neptune by the French sculptor Lambert-Sigisbert Adam (1700–1759) came into Frederick's possession when the collection of Cardinal Polignac was acquired for the Little Gallery. Like its companion piece – a bust of Amphitrite, a Greek sea goddess who was the wife of Poseidon and the mother of Triton – it sits atop the mantelpiece.

Merry with wine, the small gilded figure of Bacchus beneath the console table again takes up Sanssouci's playful motif.

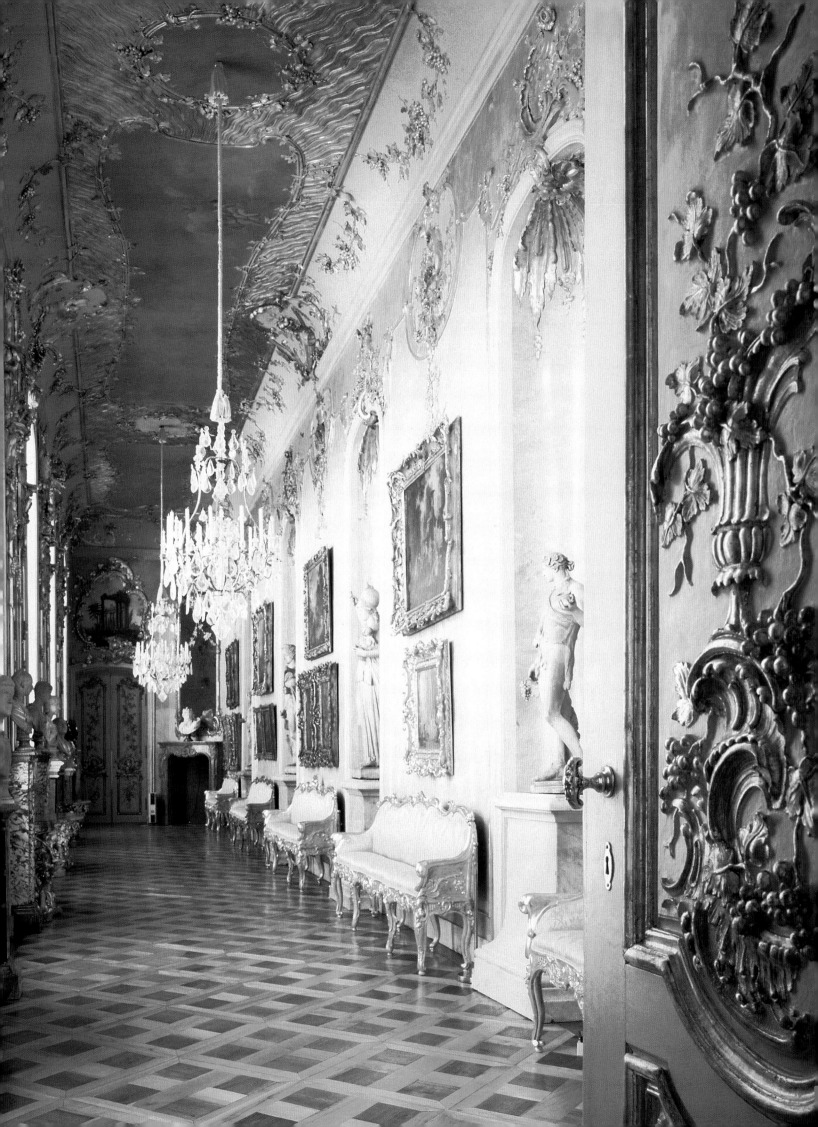

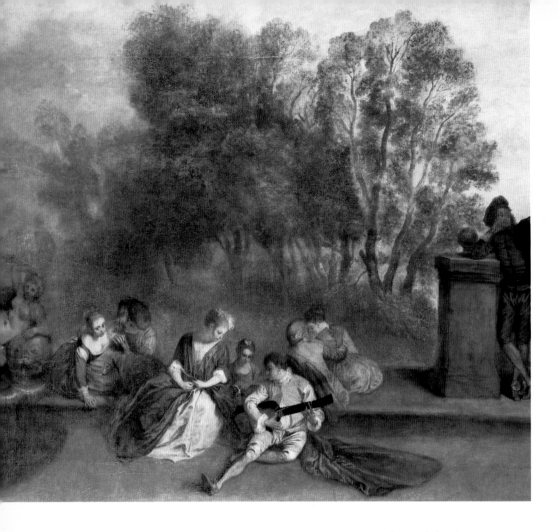

In his painting *Merry Company in the Open Air*, Antoine Watteau (1684–1721) allows the onlooker to enter the world of the Rococo. Music played in natural surroundings provides a welcome accompaniment to the sexual dalliance of the figures.

Bottom left: Detail of *Merry Company in the Open Air*.

the Great. Watteau's paintings depict a select group of people leading untroubled lives, playing music and dancing in nature's midst. At play, class differences appear to have been removed and Cupid does as he pleases. Anyone who is aware of Frederick's strict upbringing can well imagine why he longed for such a life. The gentle melancholy that pervades all of Wateau's paintings reminded the King of his own emotions.

When he was Crown Prince, Frederick, who had to buy his freedom

through marriage to a woman he did not love, celebrated "fêtes galantes" at his Rheinsberg palace along the lines of those depicted in French painting. Only wistful memories of the time were left to him when he was King at Sanssouci.

The paintings were purchased for Frederick by authorities on art such as Count Rothenburg or the Marquis d'Argens. In addition to works by Watteau, those of his pupils, Nicolas Lancret and Jean-Baptiste Joseph Pater, were further added to the royal collection. This collection of 18th-century French painting is now unique in Germany.

Les comédiens sur le champ de foire is one of Antoine Watteau's early paintings, executed when the artist still needed to find buyers for his pictures. It shows several groups of carefully painted figures in a nocturnal landscape. Although the groups are united in an effective composition, each could be made the subject of a painting offered for sale separately.

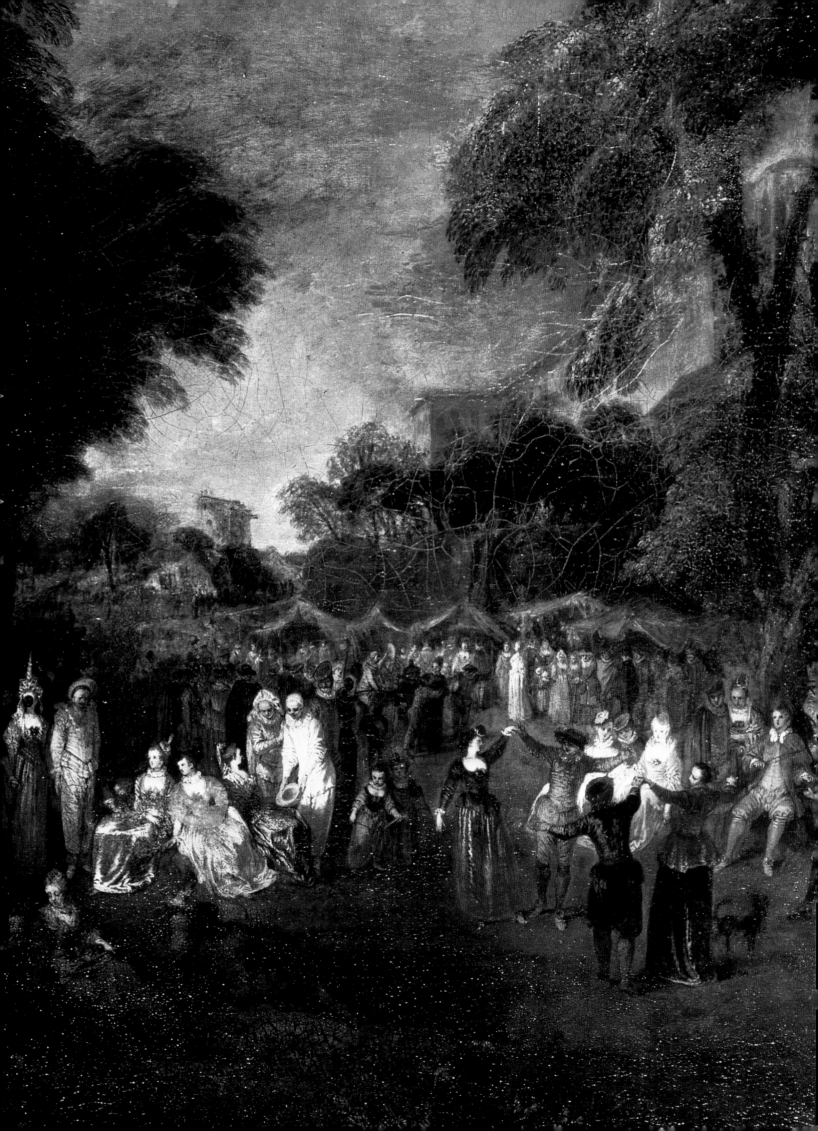

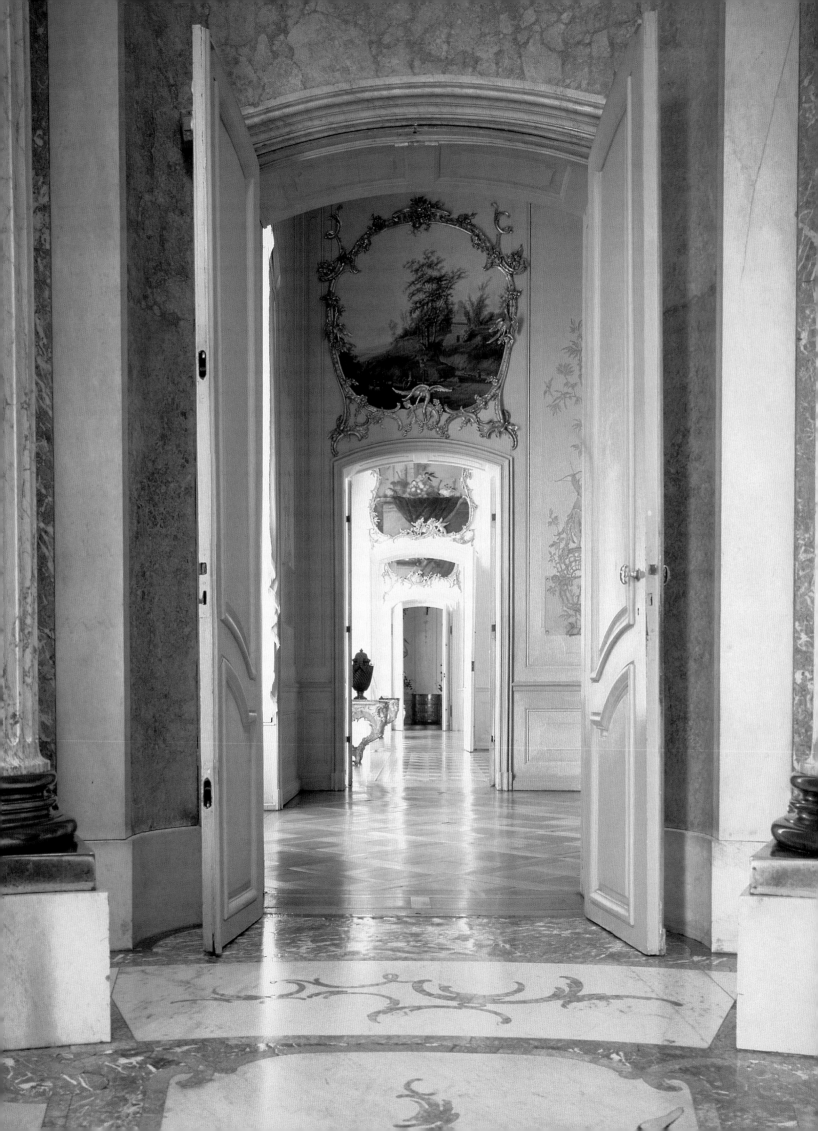

The Guest Rooms

Visiting the King of Prussia

The palace's west wing housed five south-facing guest rooms at ground level, which together form a suite, or an "enfilade". Guests had direct access to the terrace.

The figure of Cronos is a detail of the copy of the chest of drawers and clock in the Study and Bedchamber. The King had the copy made by the Swiss Johann Melchior Kambly (1718–1783) in 1749. He was an ornamental sculptor bronze founder and cabinet-maker. He specialized in fire-gilded and silver-coated bronze work, furniture with tortoise-shell inlay and furniture with bronze ornamentation as well as inlaid work with stone (Florentine mosaic)

One of the items on display is a reconstruction of an alcove for a bed. Because of the height of the room (roughly 6.5 m, just over 21 feet), the bed appears to be far too small. The servants lived in quarters immediately behind the guest rooms to allow them to attend to the guests quickly.

Just like the windows in the King's living quarters, the windows in the guest rooms open to the south. As the palace was situated at ground level, guests had direct access to the terrace. This was important because they did not want to have to walk through the servants' quarters.

There are obvious differences in style between the King's apartments and the guest rooms. The latter are very plain and are simply decorated; with the exception of the ceiling in Voltaire's Room (Flower Room), their ceilings were not painted. The guests had to content themselves with Spartan conditions – a bed, three or four chairs, a desk. In place of water, perfume or powder was used – there was no need for a bath. The chandeliers were made of glass, whereas in the King's apartments they were of the best French rock crystal.

Guests had the use of one room rather than a number of princely apartments. All the guest rooms were similar in style: opposite the windows was the alcove for the bed, and to its right there was a door through which servants could enter the room. The door on the left conceals a boxroom for storing clothes. Immediately behind the guest rooms, on the north side of the palace, the servants lived in tiny rooms.

In keeping with contemporary tastes, the first guest room contains murals with Chinese elements painted by Friedrich Wilhelm Höder (d. 1761). The vogue for "chinoiserie" also found expression in the Chinese House (Chinesisches Haus) and the Dragon House (Drachenhaus) in the palace grounds. Only a few years after the room was completed, however, Frederick II had fabric hung on the walls to provide space for paintings.

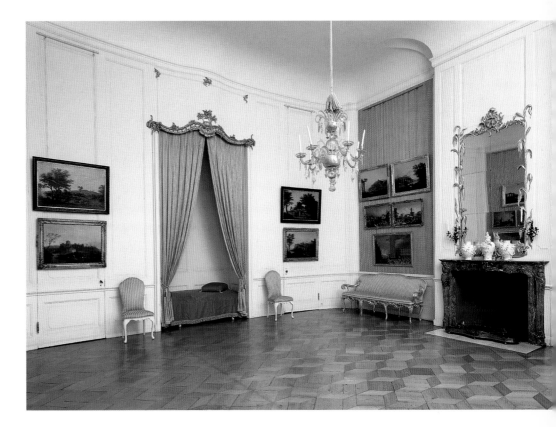

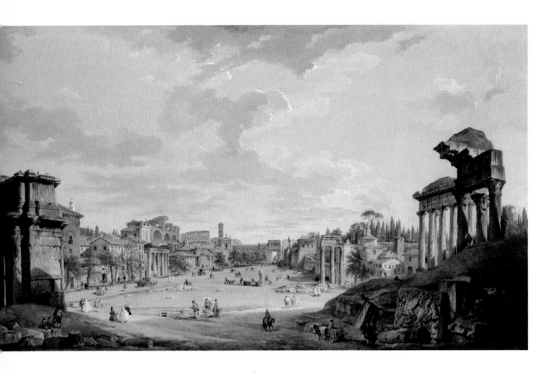

The King looked to Italian architecture for models when designing Potsdam. He also collected *vedute*, topographical views, and landscapes, such as this view of the Forum Romanum, painted by Giovanni Paolo Panini (1691 or 1692–1765) in 1749.

The second and third guest rooms are also designed to allow the display of numerous paintings. The blue-and-white-striped room contains works by 18th-century French artists, such as Nicolas Lancret and Antoine Pesne as well as two flower pieces by the Dutch painter Jacobus van Huysum from *c.* 1720.

The next room, the red-and-white-striped one, contains landscapes and townscapes that Frederick the Great often used as models or inspiration for the "work in progress" that was Potsdam.

One of the distinguished guests of the "philosopher-king of Sanssouci" was Count Gustav Adolf Gotter, seen in a portrait by Antoine Pesne in the first guest room. Shown alongside his niece, Frederika von Wangenheim, he is wearing the costume of the "Order of the Jolly Hermits", founded in 1739 at the court of Saxe-Gotha. Count Gotter was admitted to this fun-loving association, with its motto of "Long live joy", in 1743. He had already been employed at the court of Frederick William I and under Frederick the Great was known to be a witty and eccentric companion. At the same time, he held the post of Postmaster General.

Besides the daily round of dinner, celebrations were also held at Sanssouci despite the thrift exercised at the Prussian court. In Karl Heinrich Rödenbeck's diary, for instance, the entry for August 1749 reads: "At Sanssouci, Italian intermezzo. Again there, ball opened by the King and Princess Amalia. Sanssouci was illuminated. Italian intermezzo. Concert."

Come a new century, come a new King. After 1835, Crown Prince Frederick William (IV) and his wife, Elizabeth of Bavaria, used the guest rooms at Sanssouci as their summer residence. Around this time, plans to remodel and extend the palace were drawn up, and they were realized following Frederick William's accession to the throne in 1840. Architects Ludwig Persius and Ferdinand von Arnim created the Ladies' Wing and the Palace Kitchen.

The guest rooms took on new functions: the first guest room became the King's drawing room; the second guest room was turned into the Queen's

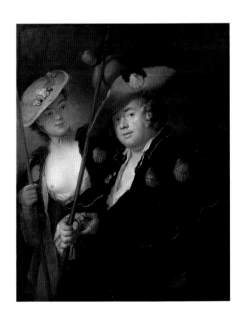

A welcome guest at Sanssouci was Count Gustav Adolf Gotter, shown here with his niece Frederika von Wangenheim, in a portrait by the court painter Antoine Pesne, *c.* 1755.

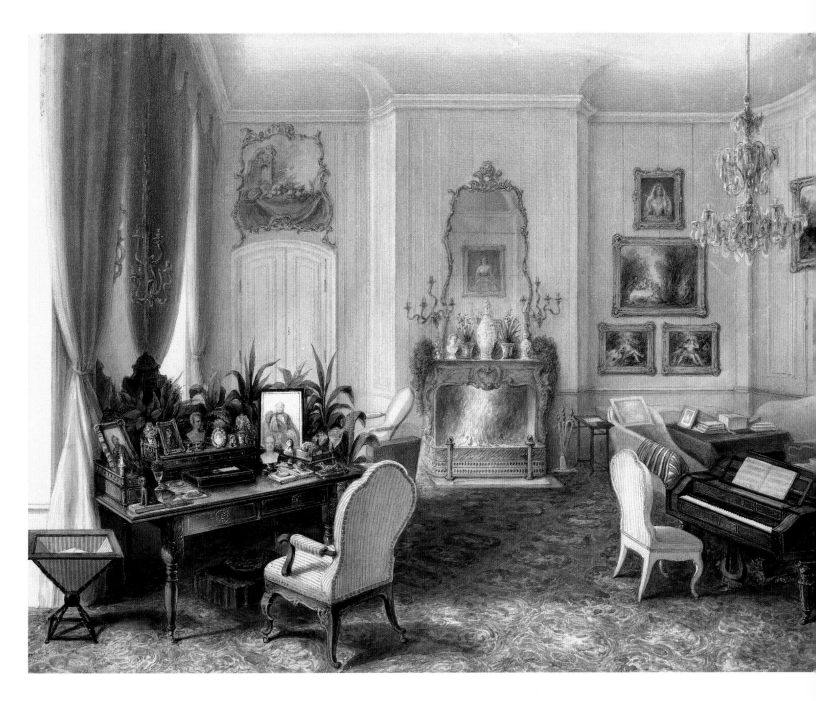

Barely recognizable: the blue-and-white-striped guest room as the drawing room of Queen Elizabeth of Prussia in the 19th century.

drawing room; the third guest room became the royal bedchamber; and the room once used by Voltaire was transformed into the Queen's dressing room. Furnishings from the mid-19th century complemented the otherwise intact Rococo interior. Sanitary installations, such as the shower in a former dressing room and water closets, were subsequently fitted. Like Frederick II, the ancestor he so greatly admired, Frederick William IV also died at Sanssouci, on 2 January 1861. His widow used the palace as her summer residence until her own death, in 1873.

A Touch of Silk

Architects in the 18th century strove to create complete works of art in which buildings, their interiors and everything within them formed a harmonious whole. This is especially true of the use of fabrics at Sanssouci, where the same fabric was used for wall coverings, bedspreads, curtains and chair coverings.

In the 17th century, Italy was the leading silk producer, a role held by France in the 18th century. The art of silk weaving arrived in Brandenburg-Prussia with Huguenot refugees from France after 1685 (Edict of Potsdam); the first mulberry trees were planted in Prussia during the reign of Frederick William I, the "Soldier-King". The silkworm moth lays its eggs in the foliage of the mulberry, a tree from warmer climes, and there, inside a silk thread cocoon, its larvae pupate. Mulberry bushes were planted in earth embankments in Berlin, Spandau and churchyards.

After acceding to the throne in 1740, Frederick the Great began to support the production and manufacture of silk in Prussia. He hoped such a valuable commodity would lead to improved trade, which in turn would boost the state's revenues.

The King had the severely depleted stock renewed and, at the same time, had new plantations established. There were plans, for instance, for a plantation of 6,000 trees outside Oranienburg. At Potsdam in 1785, there were no less than 1,003 mulberry bushes in the grounds of the Large Orphanage. The task of breeding the silkworms fell mainly to superintendents, preachers, schoolmasters and sextons who in turn were supervised by the war office and the administration of state property. Following the French example, medals and commemorative coins were awarded as incentives to achieve especially good results.

To give Prussia an economic boost, certain restrictions were imposed on foreign goods. If a Prussian manufactory was able to produce an article successfully, imports of the same foreign article were even banned altogether. To improve the quality and efficiency of Prussia's manufactories, foreign, especially French, specialists were recruited.

Great importance was attached to deliveries of Prussian silk abroad. Here, too, generous conditions applied that acted as incentives for the manufactories. Prussian silk found buyers in royal houses in Poland, Russia and Gdansk, among other places.

Satinette, satin, damask and velvet were used as coverings and they could be richly trimmed with gold or silver braid or fringes. Pastel shades in particular were popular for interior decoration in the 18th century. Frederick the Great especially liked sky blue, pink, peach-blos-

A particularly rich wall covering in the Audience Chamber; half-silk wall coverings were used in the guest rooms.

som, pale grey-green and silver. Natural substances were used to dye silk material whose patterns were often used time and again. This is why some motifs are found in other Prussian palaces, albeit in different colours.

A single company in Berlin manufactured the silk furnishings needed for Sanssouci, built at the beginning of Frederick the Great's reign. The New Palace (Neues Palais), built twenty years later, after the Seven Years' War, was fitted out by about ten different silk weaving mills. Differences are apparent in the quality of the silk used in the furnishings for the King's apartments and those for the guest rooms, where, among other things, half-silk was used.

Because the rooms at Sanssouci face south, silk fabrics and coverings last on average between only thirty and forty years. Strong light, changes in temperature, humidity and pests eventually destroy the fabric. Even in the 19th century, high curatorial standards were set in Prussia's palaces and silk fabrics were often faithfully copied down to the last thread.

Braid, fringes, cords or tassels are either handmade by trimmings (*passement*) makers or by using special machines.

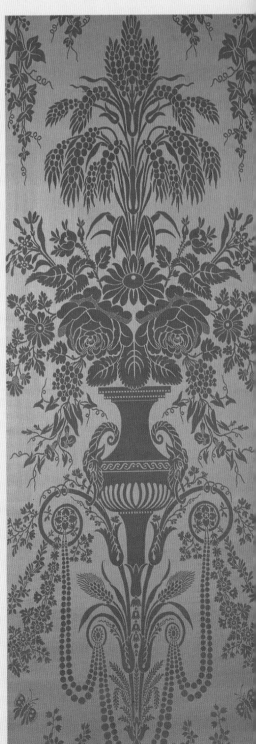

Only a close look reveals the wealth of motifs, some of which were re-used in other palaces, albeit in different colours.

Braid, fringes and tassels also suffer from the ravages of time. Shown here is part of the fringe in Voltaire's Room (Flower Room), before and after renovation.

"Voltaire's Room"

The fourth guest room is rather special. In contrast to the other rooms in the palace, here the elaborate and varied rocaille work has all but disappeared. Instead, nature reigns here in its original forms. A wealth of fruit, flowers and garlands as well as native and exotic fauna are on display in natural colours, rather than appearing in gleaming gold leaf. Ornately carved, they add life to the yellow walls. The flower motifs are taken up again on the ceiling, where they are either made of stucco or painted sheet steel and, bound into a loose garland, hang down just as they would from a trellis. In old descriptions, this guest room was called the "Flower Room" on account of its decoration.

Until 1753, the room was graced with silver-coloured Rococo decoration on its walls and silver-plated furniture, which certainly testified to the King's unconventional taste. The original ornamentation, "heightened with fine silver", is still visible in the alcove for the bed.

Voltaire's Room takes its name from the mistaken belief that the renowned French philosopher and poet lived in it during his sojourn at Potsdam.

The original painted ornamentation can still be seen in the alcove of Voltaire's Room.

The theme of nature is vividly taken up again on the ceiling. A floral wreath of intricately painted stucco and sheet steel appears to float above the room.

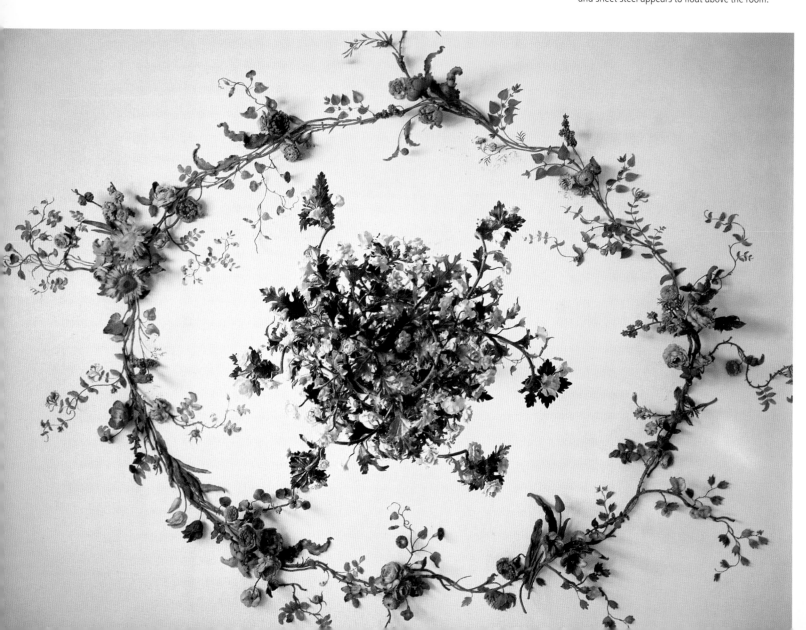

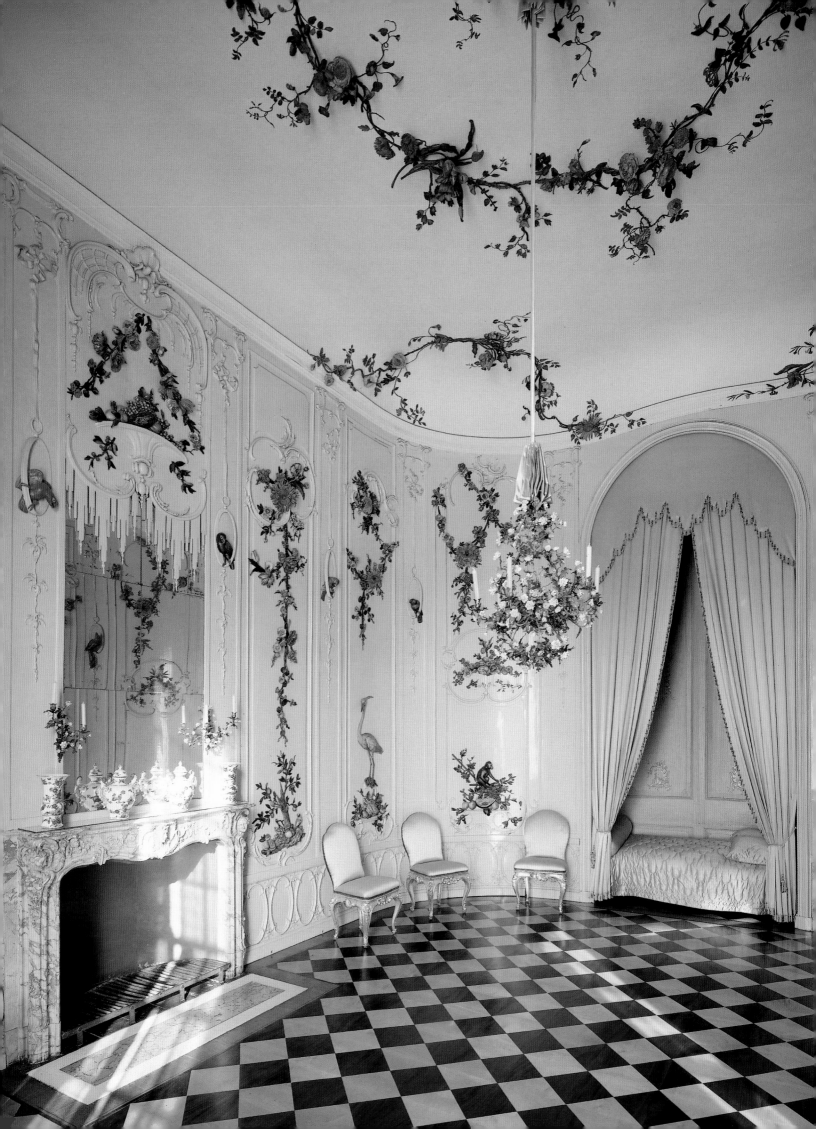

Cherries in March

The ornately carved fruit reliefs in Voltaire's Room gives some indication of the wealth of fruit grown by Frederick the Great. In summer, 700 tubs containing orange trees stood on the terraces in front of Sanssouci alone. In addition to vines and figs, there were peach and apricot trees trained on stakes. To ensure a supply of dessert fruit before it ripened naturally, after 1772 the growing areas were glazed in. Frederick's resourceful gardeners also devised storage rooms in which grapes harvested in November would keep until the following February. In addition, the palace grounds contained hothouses for melons, bananas and pineapples. Cherries, plums and other fruit ripened early against sheltered walls. Only thanks to these measures was it possible to have a daily supply of fresh fruit on the King's table or to offer a gift of fruit from the hothouses to esteemed visitors. Frederick once surprised his mother on her birthday, 26 March, by presenting her with a bowl of freshly picked cherries.

Previous page: With its woodcarvings of flowers and animals by Christian Hoppenhaupt the Younger (1719–1778/86?), the fourth guest room is something of a surprise. The naturalistic effect is further heightened by Augustin Dubuisson's (1700–1771) painted decoration.

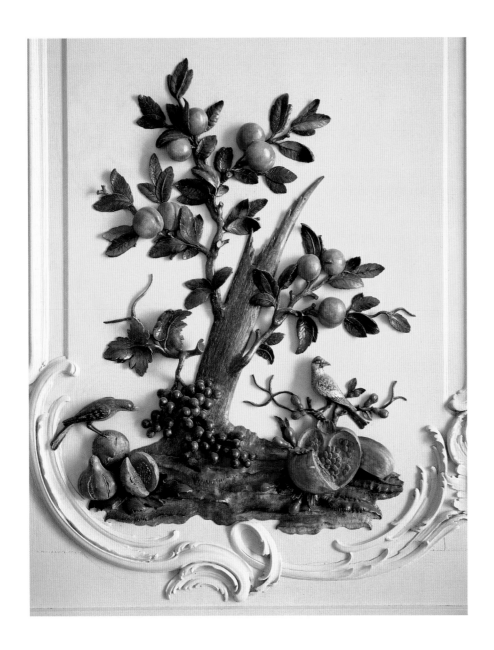

"Red muscatel", an ancient variety of vine that was cultivated in the 18th century.

An example of the elaborate woodcarvings adorning Voltaire's Room.

The "Ladies' Wing"

Architectural History

Immediately on his accession to the throne, in 1840, Frederick William IV chose to make Sanssouci his summer residence. He and his wife, Elizabeth of Bavaria, lived in the palace's guest rooms. At the same time, the king required alterations to be made to the side wings.

Like Frederick the Great before him, Frederick William IV took an interest in architecture, but unlike his ancestor, his ideas on architecture were also political in nature and often remained pipe dreams. Not for nothing did he enter the history books as the "Romantic on the throne". Exceptionally musically gifted, he enjoyed a liberal education thanks to his unconventional mother, Queen Louisa. He said himself that he would rather have been an architect than King. With some self-deprecation, Frederick William did not refer to himself as the "Dauphin", as did others in line for the throne, but as "Butt" ("Tubby") on account of his portly figure.

On his accession to the throne in 1840, Frederick William IV moved into the guest rooms at Sanssouci; that same year, he had another storey added to the side wings. On one side, the Ladies' Wing housed the guest rooms and, on the other, the palace kitchen.

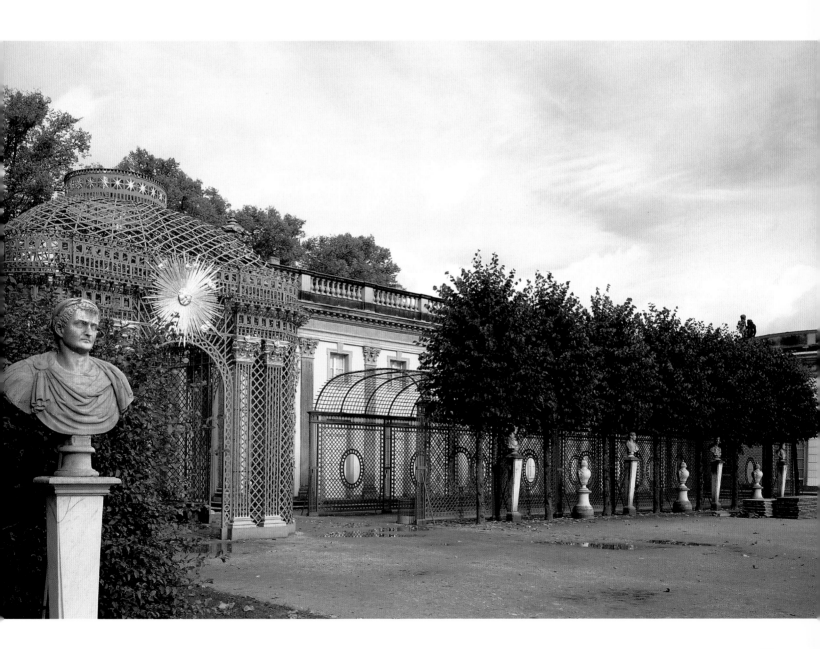

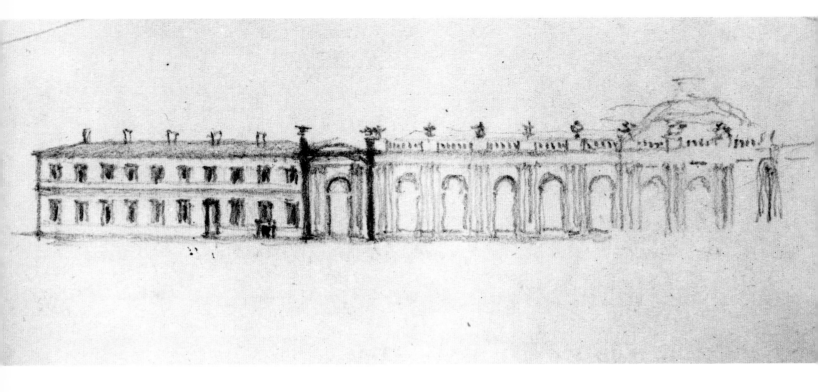

Even as a child, he developed a strong admiration for his great-great uncle. To live in "heavenly" Sanssouci allowed Frederick William IV to get closer to Frederick II and his world. To reign in the palace of his illustrious ancestor was not only a great honour for him, but also a means to legitimize the royal claim to power that was now coming under question.

Because of his high regard for Frederick the Great, Frederick William IV was extremely sensitive in his approach to the alterations of the side wings. It is obvious even from the preliminary drawing that his aim was to achieve a unified whole that would be in keeping with Knobelsdorff's original plan.

The new architects, Ludwig Persius and Ferdinand von Arnim, both pupils of the great Prussian architect Karl Friedrich Schinkel, skilfully set about their new task. Concealed behind the pergolas on the garden side, the side wings match the original palace building in height and proportion and even from the courtyard, it is not obvious that they are later additions.

In one of his first sketches, Frederick William IV put onto paper his ideas for the redesign of the side wings at Sanssouci. The extension was to be in the same style as the original palace.

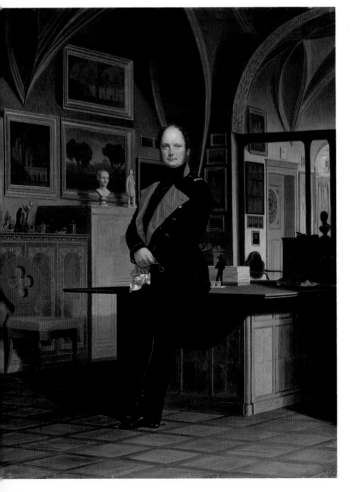

Franz Krüger's (1797–1857) portrait of c. 1846 shows Frederick William IV in his study in the palace at Berlin.

The writing table with its rosewood side table stands in one of the upstairs guest rooms. It once stood in Queen Elizabeth's drawing room in Potsdam's Stadtschloss and is an example of the contemporary style at court. They were a gift to Elizabeth from the Russian tsarina, a sister of Frederick William IV.

"Water closets" were the latest novelty in the mid-19th century; installing them in the guest rooms caused something of a sensation.

Personal items belonging to the royal couple are laid out on the writing table from the White Room. The album-shaped stationery box still contains sheets of paper that belonged to the Queen and the small, blue notebook contains the last pencil markings made by the then seriously ill King.

The "simple Rococo style"

At Sanssouci, Frederick William IV deliberately harked back to the age of Frederick the Great. As in the main palace, the servants' quarters lay to the north and the south-facing apartments housed members of the court.

Together the individual guest rooms form an enfilade that, very much in the Baroque manner, created a vista when all the doors were open. When it came to furnishing the guest rooms, Frederick William IV wanted to retain the "simple Rococo style". Besides elegant German items, the rooms contained ornately decorated furniture from St Petersburg.

A reflection of contemporary tastes, a number of small sculptures and paintings adorn the guest rooms. Numerous ornaments and utensils that found their way into the royal household either as gifts or mementos offer a glimpse of the royal couple's private life. The only concession to modernity seems to be the "water closets", which were a novelty in the mid-19th century.

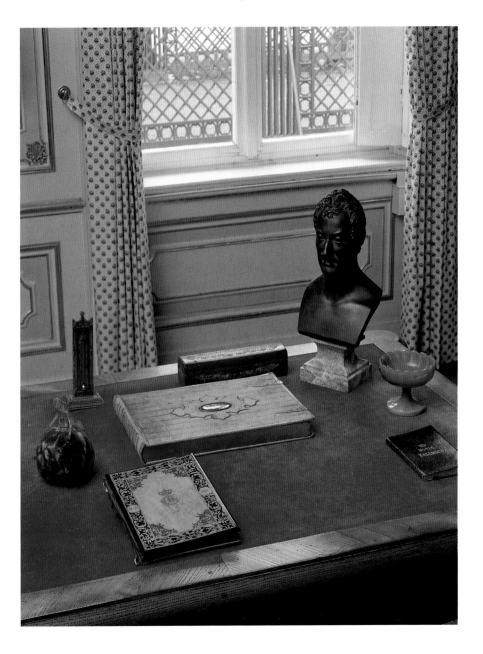

The "Traumzimmer" – "... a veritable gem of fine taste"

A dream prompted King Frederick William IV to commission Ludwig Persius to furnish and decorate a room in the Hofdamenflügel. When he did so, he had in mind Frederick the Great's green-panelled room at Charlottenburg Palace, which was used as a tea room. In his dream, the room was "green and decorated with silver, a veritable gem of fine taste". Persius's first design did not do justice to the King's dream. "You know, I once saw this room in my dreams. That is why we are going to carry this through to completion." In the way it is appointed, the Traumzimmer has come down to us essentially intact. The green wall panelling is framed by silver-plated mouldings and contrasts with the crimson upholstery and curtains. On the King's instructions, Persius's simpler design was realized in the room above the Traumzimmer.

Reflections in the Traumzimmer.

Frederick William IV once saw this room, the Traumzimmer (Dream Room), in a dream. Some time later, his dream was realized at Sanssouci.

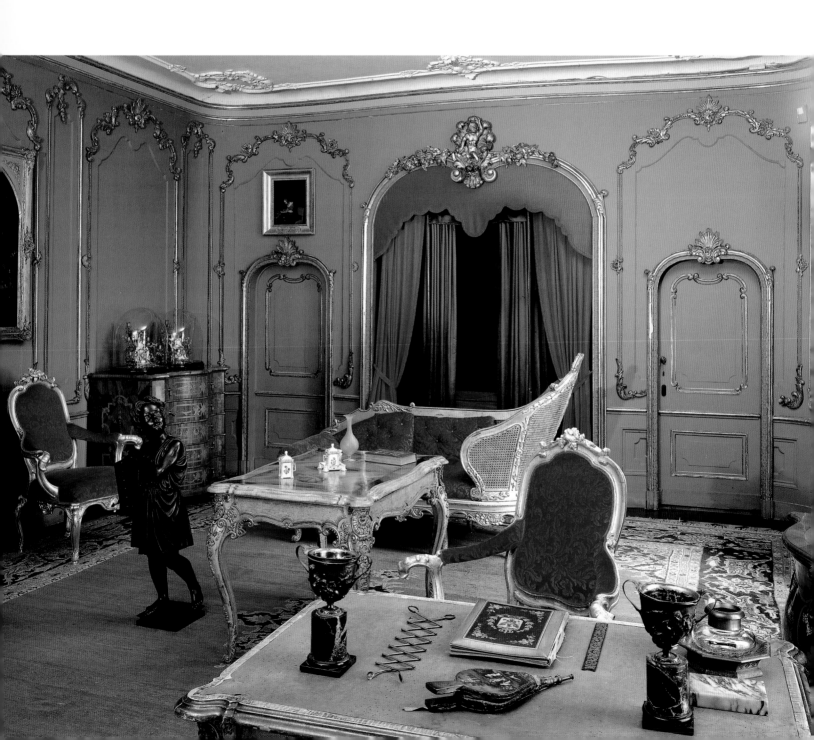

The Portrait of Princess Louisa of Prussia

An important collection of paintings from the Biedermeier period (1815–48) is now housed in the north-facing servants' quarters. Besides Karl Blechen's (1798–1840) delicate landscape sketches, it is mainly Karl Wilhelm Wach's portrait of Princess Louisa of Prussia – sitting gracefully composed upon a throne-like chair – that charms visitors.

Her feet rest on a fine silk cushion. Displaying great skill and painstaking care, Wach deals with every last detail of his subject. One is tempted to run one's hand over the silk dress just to feel how soft it is!

As in Renaissance paintings, through a window we see an outside view, in this case the terrace at Sanssouci and a bowl of oranges in the foreground. Such detail is a reference to the sitter's royal origins as a Prussian princess, whereas the bridal wreath she is holding is a reference to her impending marriage. The portrait was, in fact, an official commission to mark her marriage to Frederick, Prince of the Netherlands. As such it has an essentially representative function and Wach painted it in the style of Baroque state portraits. Yet the regal insignia, such as the ermine cloak, the crown and the palatial architecture in the background, seem like accessories because the young bride's girlish charm sits uneasily beside them. It is this incongruity that gives the picture its appeal and marks the Princess out as the daughter of Queen Louisa of Prussia, a woman whose beguiling charm and charisma are talked of to this day.

Louisa of Prussia was the lovely daughter of Queen Louisa. Karl Wilhelm Wach (1787–1845) painted her in bridal attire in 1825.

As a sign of her approaching marriage, the Princess is shown holding a bridal wreath.

The decorative fruit bowl containing oranges and orange blossoms is a reference to the coming marriage of the Prussian Princess and Frederick of the Netherlands from the House of Orange.

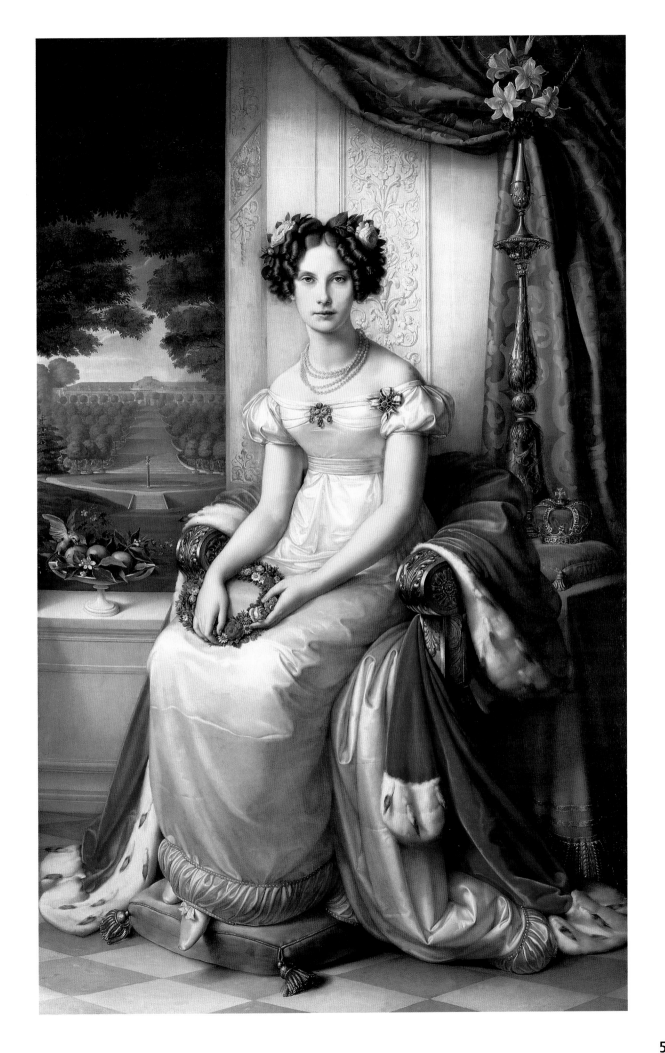

The Palace Kitchen

A Dish fit for a King

When he acceded to the throne, in 1840, the Prussian King Frederick William IV chose to make Sanssouci his summer residence. Unlike his great model, however, he wanted to share the palace with his wife and a small court. Some alterations to the building were therefore necessary. By 1842, the architects Ludwig Persius and Ferdinand von Arnim had created the large Palace Kitchen with its adjacent bakehouse. In the cellars, they installed a confectionery, ice-making facilities and wine cellars. Besides storerooms, there were also a coffee-roasting room, a candle-making room, a linen room and a silver-cleaning room.

In use only until the death of Queen Elizabeth in 1873, the Palace Kitchen to this day contains its original fittings; only the spits have since been removed. The blue and white colour scheme pays tribute to the Queen's Bavarian origins.

The showpiece among the kitchen's fittings is the cooker with its brass mountings and the brass rod enclosing it. So-called economical kitchen-ranges were developed as late as the mid-19th century, making this one one of the most up-to-date of its kind. In contrast to open fires, it saved a lot of fuel because it was enclosed.

A special feature of this cooker is its ease of access from all four sides. This allowed the palace cooks to work free of obstruction and to put the cooker's various heating areas to best use. There were a number of hotplates, roasting ovens, a small spit, hot cabinets and a trough with a constant supply of hot water.

Food was often cooked using copper utensils. To prevent verdigris poisoning, great care was taken to ensure that the pots and pans received regular coatings of tin. Moreover, the cooks used utensils made of brass, iron and tinplate.

During the 19th century, food for the royal table at Sanssouci was prepared in the Palace Kitchen, which measures about 115 m² (over 1,200 square feet). Frederick the Great's kitchen was a good deal smaller and was situated in the west wing of the palace.

This figure of Victory with a laurel and a palm branch, a popular motif around 1850, can be found on the cooker's oven door on the far right.

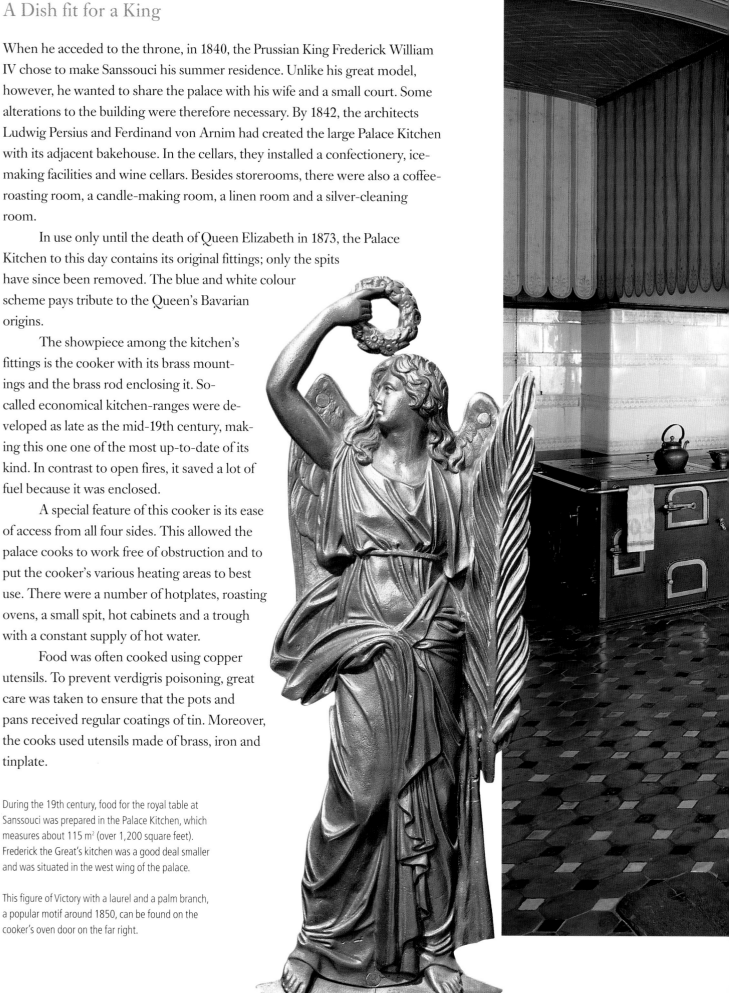

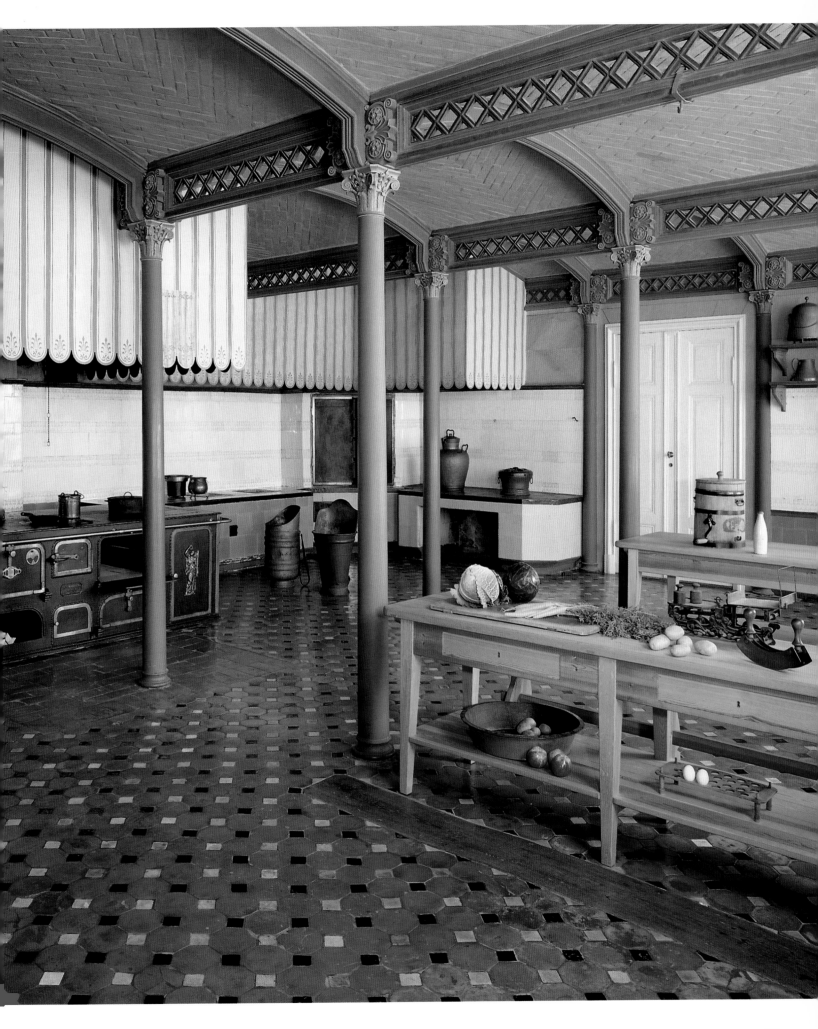

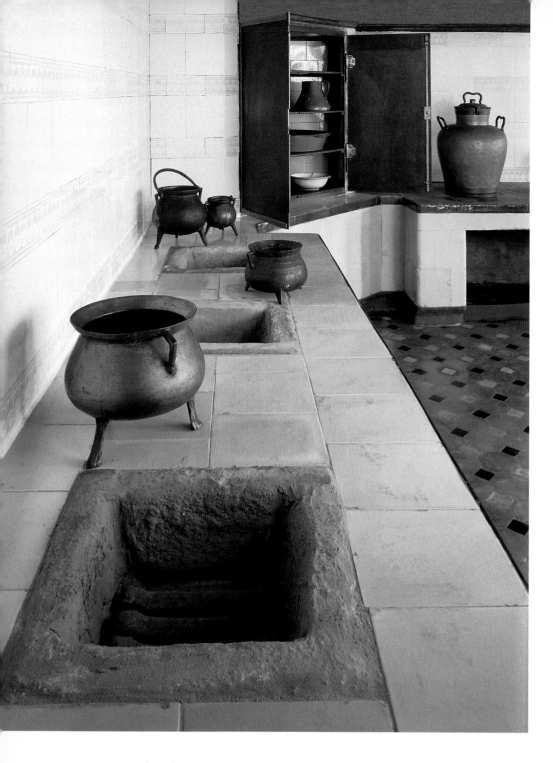

So-called Castrol ovens, the predecessors of the cooker illustrated on the previous pages, enabled food to be cooked on grates over the fire. Hot cabinets were used to keep cooked food warm and to heat the porcelain dishes.

Rather than as a mincer, pestles and mortars were used to grind shellfish; they were also used for crushing salt, which was delivered in large blocks. Unlike wood, marble does not absorb smells and is ideal for use in the kitchen.

Set into the floor in front of the windows are wooden planks that were intended to prevent the kitchen staff's feet from getting cold where they stood and worked. The original pine desks with beech tops that once stood here have now been replaced by replicas.

The head chef was in charge of the kitchen and had an office just off it. He supervised some thirty employees who served at court as kitchen scribes, cooks, cellarmen or errand-girls and dishwashers.

Fedor von Köppen was a young officer who was often invited to take part in the intellectually stimulating discussions conducted at the King's dinner table. He has left an account of the routine at Sanssouci under Frederick William IV on days when there was no state visit or other cause for celebra-

An oversized pestle and mortar was used to crush shellfish and salt.

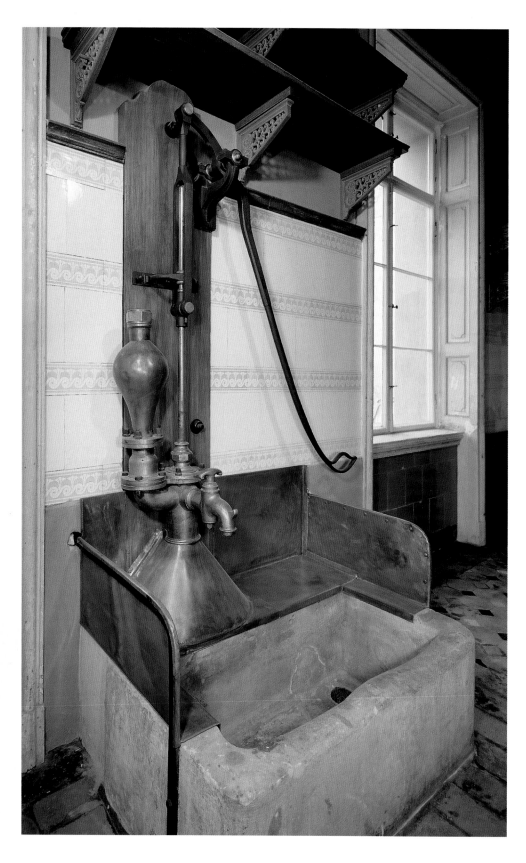

This pump was installed to ensure a constant supply of fresh water. Until its installation, water was carried in from a well near the kitchen.

tion. "The table was not specially set for dinner; instead only two straw place-mats were laid for each guest, a round one for the porcelain, an oblong one for the cutlery. Only one dish was served. The King drank no wine in the evening, but at most two glasses of Champagne." The King lived at Sanssouci from May to November and it was then that the kitchen was used. As the palace's rooms were not large enough to hold state banquets, Sanssouci was instead chosen as the venue for birthday celebrations and family gatherings as well as the royal

Cooker dating from c. 1850.

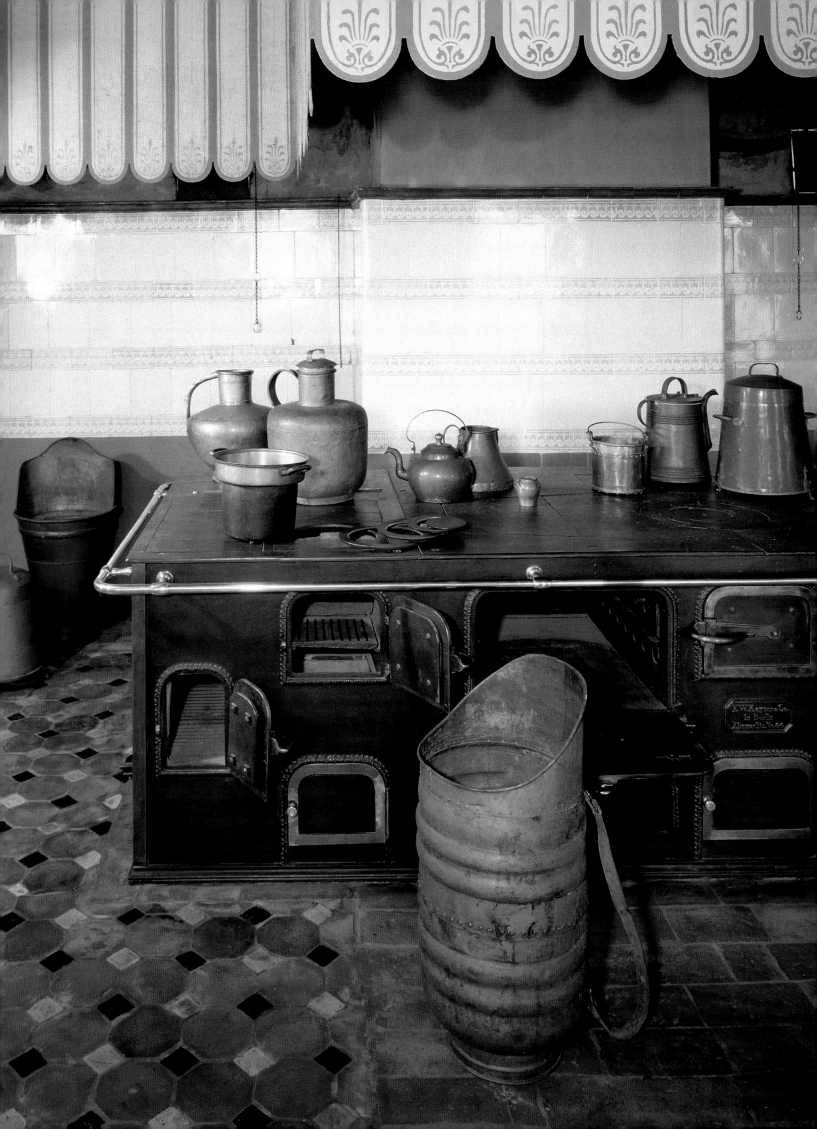

In addition to the bakery, the domestic quarters housed a confectionery, ice-making facilities and wine cellars.

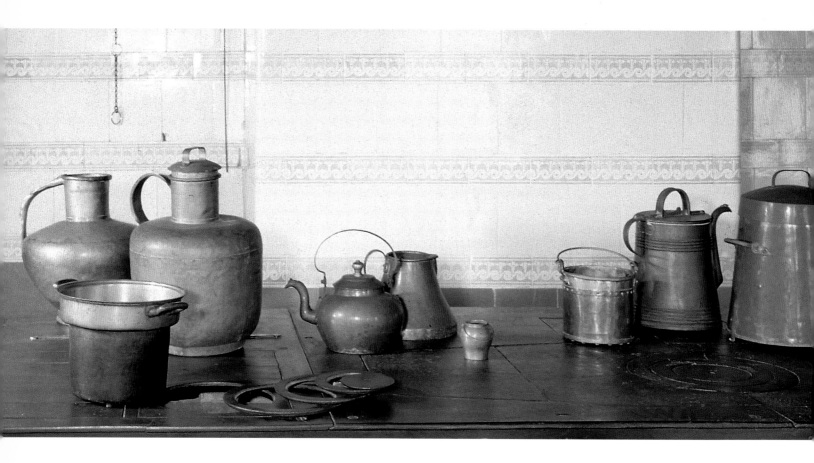

couple's silver wedding anniversary, the King's 60th birthday and his 50th anniversary as head of the Army.

The bakery, itself divided into two rooms, is situated next door to the large kitchen. The room at the rear houses the oven that, as was common at the time, was heated using hot stones, charcoal or brushwood. To allow work in the front room to continue despite the oven's great heat, a glazed door was fitted. In the workroom, there was originally a movable table with a marble top. The bakery would certainly have been used to make bread and biscuits as well as pies, which were also very popular in the 19th century. A spiral staircase led down into the confectionery, which was situated directly beneath the bakery. The cooler rooms in the basement were ideal both for it, the ice-making facilities and the wine cellars.

Kitchen utensils dating from c. 1850.

Thanks to Frederick William IV's delight in drawing, we know what was served at the royal dining table in the 19th century. Menus were printed only for special occasions. For everyday use, a handwritten note sufficed: "meat broth, lapwings' eggs, capon with oysters, green beans with sweetbreads, loin of veal with kidneys, cake, compote, salad".